CAMBRIDGESHIRE
FROM THE AIR

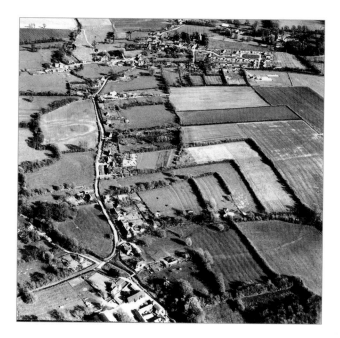

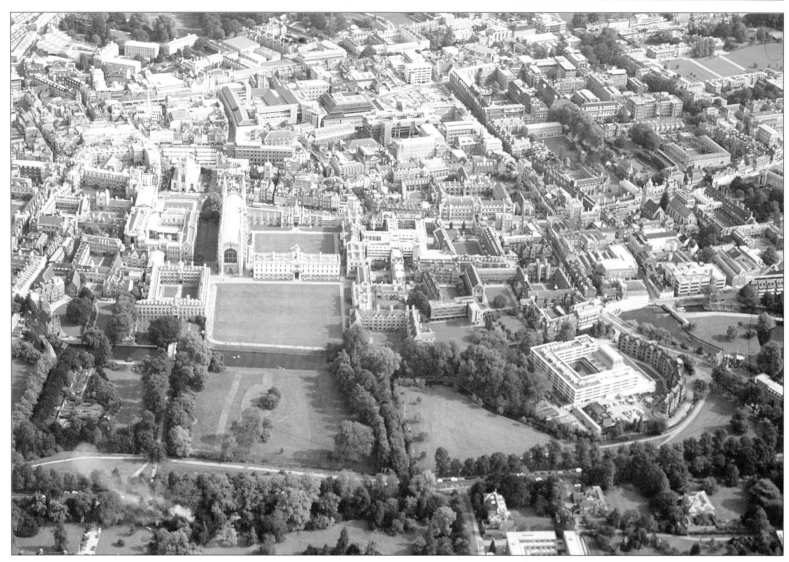

2 THE MEDIEVAL COLLEGES OF CAMBRIDGE UNIVERSITY (E)

CAMBRIDGESHIRE
FROM THE AIR

SUSAN OOSTHUIZEN

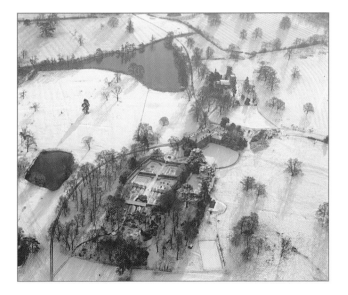

UNIVERSITY OF CAMBRIDGE
COMMITTEE FOR AERIAL PHOTOGRAPHY

ALAN SUTTON PUBLISHING LIMITED

First published in the United Kingdom in 1996
Alan Sutton Publishing Limited · Phoenix Mill · Far Thrupp · Stroud · Gloucestershire
in association with
University of Cambridge Committee for Aerial Photography

British Library Cataloguing in Publication Data

A catalogue record for this book is available from the British Library
ISBN 0–7509–1064–X

Illustrations: p. i, 1 Late medieval fields, Bourn (SE); *p. iii,* 3 Croxton Park in snow (E).

The author and the publisher wish most gratefully to acknowledge the kindness and support of Mr David Wilson, working for the Cambridge University Committee for Aerial Photography, without whose help and encouragement the publication of this book would not have been possible.

Typeset in 11/14pt Perpetua.
Typesetting and origination by Alan Sutton Publishing Limited.
Printed in Hong Kong by Midas Printing Limited.

CONTENTS

4 DUXFORD: INDUSTRIAL WORKS, CIBA GEIGY (W)

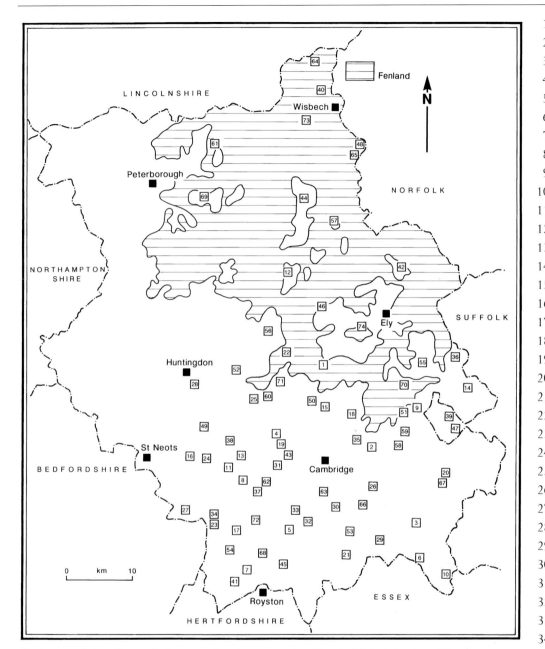

1. Aldreth
2. Anglesey
3. Balsham
4. Bar Hill
5. Barrington
6. Bartlow
7. Bassingbourn
8. Bourn
9. Burwell
10. Castle Camps
11. Caxton
12. Chatteris
13. Childerley
14. Chippenham
15. Cottenham
16. Croxton
17. Croydon
18. Denny
19. Dry Drayton
20. Dullingham
21. Duxford
22. Earith
23. East Hatley
24. Eltisley
25. Fen Drayton
26. Fulbourn
27. Gamlingay
28. Godmanchester
29. Great Abington
30. Great Shelford
31. Hardwick
32. Harston
33. Haslingfield
34. Hatley St George
35. Horningsea
36. Isleham
37. Kingston

38. Knapwell
39. Landwade
40. Leverington
41. Litlington
42. Littleport
43. Madingley
44. March
45. Melbourn
46. Mepal
47. Newmarket
48. Outwell
49. Papworth St Agnes
50. Rampton
51. Reach
52. St Ives
53. Sawston
54. Shingay
55. Soham
56. Somersham
57. Stonea
58. Swaffham Bulbeck
59. Swaffham Prior
60. Swavesey
61. Thorney
62. Toft
63. Trumpington
64. Tydd St Giles
65. Upwell
66. Wandlebury
67. Westley Waterless
68. Whaddon
69. Whittlesey
70. Wicken
71. Willingham
72. Wimpole
73. Wisbech St Mary
74. Witchford

The location of places illustrated. Please note that places are numbered here in alphabetical order and that these numbers do not necessarily correspond with the number on each caption.

(Map drawn by Philip Judge)

INTRODUCTION

The Cambridgeshire landscape is a beautiful and subtle one, whose range and variation is a surprise and a delight. The uplands combine distant views across the River Cam and its tributaries with intimate enclosed valleys. There are low-lying areas of marsh within a few miles of ancient woodland, complete with coppice, pollard and woodbanks. Large, open villages on downland slopes are set in seemingly limitless arable fields, which may yet include medieval ploughland now preserved as pasture, and all almost within sight of the dispersed hamlets of the wooded clay plateau.

This modern landscape is the result of centuries upon centuries of man's activity within and upon it. The apparent uniformity resulting from modern farming and industrial development is deceptive, and the aerial photographs selected for this book demonstrate the underlying antiquity. They provide a new perspective which brings the past alive within the present, and they record a man-made landscape which was already old 4,000 years ago and in which traces of distant periods still survive.

THE CONFINES OF CAMBRIDGESHIRE

The Cambridgeshire county boundaries were expanded in 1974 to include most of Huntingdonshire and parts of Northamptonshire. Recent local government proposals intimate that Huntingdonshire may be reconstituted, restoring Cambridgeshire to its original size. This ambivalence about what Cambridgeshire should include has blurred the boundaries of this book. Almost all of the views printed here would have been found within the 'old' boundaries which pre-date 1974. Nevertheless, there are inclusions from the 'new' county, particularly of the towns which joined Cambridgeshire twenty-one years ago: Godmanchester, Huntingdon, Peterborough, St Ives and St Neots. Half of Royston parish also used to lie in Cambridgeshire as it lay north of the Icknield Way, the old county boundary, but modern boundary changes have rationalized this division and Royston now lies altogether in Hertfordshire – although partially reclaimed here.

THE TOPOGRAPHY AND GEOLOGY OF THE CAMBRIDGESHIRE LANDSCAPE

The ways in which man has used and made his mark on the local landscape are deeply affected by the underlying geology and the lie of the land – that is, the topography of the area. As Cambridgeshire falls into two main geographical areas – upland and fen – I shall deal with each of these in turn.

The dominant feature of Cambridgeshire south of the fens – the upland – is the valley of the River Cam and its tributaries. The Cam (also called by its Celtic names, Granta and Rhee) is made up of a number of rivers and streams: the Ashwell Cam rises in the south-west of the county and flows in an easterly direction until it reaches Barrington, where it begins to flow north and out towards the sea; it is joined at Great Shelford by the Essex Cam (flowing up past Ickleton and Whittlesford) and the River Granta, which has made its way west from Linton and far beyond. The land on either side of the river and its tributaries was reasonably light and easily worked, being a mixture of gravel and alluvial soils which had been brought down by the water through the millennia.

The southern and eastern reaches of the River Cam are enclosed by the broad sweep of a wide chalk ridge, along which the Icknield Way runs, and from which the land rises yet further towards the east and the Suffolk county boundary. The chalk is dry and so relatively lacking in village settlement, but providing good pasture land for sheep and also some arable. Clay overlies the chalk on the higher ground towards the east, and this heavy ground was well-wooded in the early medieval period. To the west of the River Cam, two further chalk ridges rise up out of the valley on a west–east axis, broadening out until they join a wide clay plateau near the old western county boundary. The first and most northerly ridge carries the old prehistoric Romanized road running west towards Caxton and Eltisley from a river crossing at Cambridge. The second – divided from the first by the Bourn Brook, a tributary which joins the River Cam at Grantchester – is the marked hill which divides the parishes of Haslingfield from Barrington, Eversden and Kingston from Wimpole, and along which the prehistoric route now called the Mare Way runs. These ridges are also capped with clay on their higher reaches.

The clay plateau to which these ridges are joined, like two fingers of a hand, lies under most of west Cambridgeshire north of the Ashwell Cam valley. The line of Ermine Street more or less defines the edge of this plateau, as the Roman engineers ensured a route which would not entail more valley crossings than necessary and stuck to the uplands. Like the claylands in the east, these heavy western uplands were wooded in the medieval period.

Clay is also the underlying soil of the fens. There the generally flat basin

is interrupted by occasional areas of higher ground, islands above the floods which became increasingly common from about 6,000 BC onwards. As sea-levels rose, so the broad rivers which carried upland waters out to the sea across the flat fenlands were unable to disgorge the water quickly enough into the sea and fresh water began to back up in the fen basin, causing localized flooding and ponding. Peat began to form in the central fenland as trees and other vegetation fell into the waters and rotted. Gradually the peat-covered areas spread southwards, eventually covering the natural clay surface where it lay below about 12 feet above sea-level. This process continued until about AD 1650 (after which widescale drainage began), creating thicker layers of peat in the central fenland and thinner layers near the uplands. Peat-based fenland was a rich resource for farmers, who could graze cattle and sheep on the sweet hay meadows caused by winter flooding, as well as exploit the numerous other ecological niches of grasses and trees, fish and fowl, which flourished in the area.

There were also times when sea-levels were abnormally high and marine floods covered much of the northern fenland, sometimes for several centuries. Then seawater brought in clay silts, which gradually settled on the peat floor of the basin. After the sea withdrew, peat once more covered the recent silts, until the next episode of marine flooding which brought in more silt. From the late Bronze Age onwards there were three major periods of flooding in the northern fens, interspersed with periods of peat formation as sea-levels fell slightly. The results were a kind of multidecker sandwich of peat and silt in the northern fenland, which raised some areas sufficiently above sea-level for people to begin to settle on these newly formed islands when sea-levels fell once more in the middle Saxon period. The farmers of the silt fens gained all the advantages of grazing offered by low-lying pasture land nearby, the possibility of arable farming on the siltlands, and the production of salt on the seaward marshes.

Chalk, clay, gravel, peat and silt each created opportunities for local farmers, and the differences between the potential offered by each locality, together with the historical processes of expansion and contraction, created unique reactions in different parts of the county at different times, as this series of photographs will show.

A BRIEF HISTORY OF AERIAL PHOTOGRAPHY

Photographs of the landscape taken from the air have a universal appeal: to see the familiar from an unfamiliar perspective is immensely exciting. There are also sound academic reasons for studying an aerial view. First, it often makes better 'sense' of a landscape than our usual ground-based view by allowing us a total, certainly a more comprehensive, picture compared with the series of smaller vistas available to the earthbound observer. Second, each photograph is a permanent record of the landscape as it was on a particular date, and allows us to compare landscape changes over time. Third, the hedges and trees which impede our view on the ground, or the hills and valleys which hide or distort, are not necessarily obstacles from the air.

The first aerial photographs in Britain were taken by a commercial photographer called Henry Negretti from a balloon over London in 1863. Although the results were a little blurred – owing to the slow photographic processes of the time – the potential for aerial photography was soon realized and, by the late 1880s, military use of photography from balloons, with improved cameras, was a swiftly developing field.

The invention of the aeroplane in the early twentieth century transformed aerial photography – which became an established technique of military intelligence from the First World War on. Military photography was, of course, designed for military purposes, with the interesting result that for many places the earliest available photographic cover is that taken by the Luftwaffe which mapped almost all of eastern England in 1940. Like the air survey made by the RAF over Britain in 1946–7, these photographs are of great historical interest as they provide excellent documentary evidence of the state of the British landscape fifty or more years ago. Military interest in the use of aerial photographs is still intense, as the use of satellite photographs to track armies and weapons in Iraq and Yugoslavia in recent years has shown.

O.G.S. Crawford, the first Archaeological Officer of the Ordnance Survey, as well as doing some photography on his own account in 1924, made it his business to monitor military photographs for the presence of archaeological sites. He developed new skills in photo interpretation, learning to 'read' the landscape from the air, using a combination of archaeological and documentary evidence to interpret what could be seen as the end product of a long process of development through time. As editor of the magazine *Antiquity*, he published a constant stream of important new aerial photographs of archaeological sites taken by a small number of civilian fliers, like George Allen.

After the Second World War Dr J.K. St Joseph, a Cambridge University geologist, obtained assistance from the RAF in carrying out an annual programme of reconnaissance for academic purposes from 1945 onwards. St Joseph's broad vision and enquiring mind was at the base of a collection which encompasses most of Britain and Ireland and parts of Denmark, covering many subjects including archaeology – Roman

archaeology was St Joseph's special love – geology, ecology, agriculture and geography. Since he retired in 1980, his work for the Cambridge University Committee of Aerial Photography has been carried on under the directorship of Mr David Wilson, who has continued to expand the University Collection and most generously supported colleagues in similar fields with resources from the Collection.

WHY ARE ANCIENT FEATURES VISIBLE FROM THE AIR?
Aerial photography of archaeological remains works in three main areas: in recording earthworks which still stand above the ground, in recording the traces of disappeared buildings and other features in growing crops, and in recording similar marks in ploughed soil. It would in fact have been difficult to alter the shape of the ground in the past by either digging into it or building on it without leaving some clue for the modern aerial observer.

As many photographs in this book show, earthworks – which are the remains of man's activity above ground – are best viewed in raking light or under particular climatic conditions. The low sunlight of early morning or late afternoon throws their outlines into relief, so these are the best times for taking photographs. Snowfall enhances dark shadows of raised earthworks and structures seen against a white background; on the other hand, melting snow tends to lie longer in shady furrows and holes where it creates a sharp contrast with sunny areas where the snow has disappeared.

In crops, two kinds of disturbance can be seen. Where a ditch or hole has been dug, it will often become naturally silted up with accumulated composted debris, creating a richer soil with deeper access to water than the surrounding area. Even where it has been filled in by man, the original hole will allow roots to grow deeper in search of water than in the rest of the field. It follows that crops growing over features dug into the ground will grow taller and denser and remain green for longer than crops growing on an undisturbed surface, and that hidden features will be shown by green lines or dots in a yellow field of ripening corn. The ditches surrounding a Second World War searchlight base (see picture 131) provide an excellent example.

By contrast, the soil is shallower over walls or other solid structures which have fallen down and gradually become covered by earth. Even though nothing may be visible at the surface, from the air the parched parts of the crop overlying these buried features, whose roots have been unable to penetrate as far as the rest of the crop, will show yellow against a green background. These marks are the more highly prized, as they follow long, dry summers and are more rarely seen.

Finally, there are also discoveries to be made from the air in ploughed soil. Where the ground has been disturbed, for example by holes or ditches which have later been purposely or accidentally filled in, the infill is very often a different colour from the surrounding soil. The reasons are various. In Cambridgeshire, the three most common are:

(1) in upland areas, a depression was originally filled with wood since rotted (for example, in the case of a timber-framed structure as at Harston (33)), or it may have become filled up over the years with plant matter which has decomposed to a generally darker colour than that of the surrounding soil;

(2) in the peatlands, that silt brought into the area during flooding may have settled in a depression, filling it with a lighter coloured soil than the darker peats, as at Upwell (31);

(3) stone walls may stand out against the soil in which they were erected, as at the Roman villa at Reach (28).

However, a word of warning applies to all of these generalizations: not all soil and crop marks are the result of man-made changes to the landscape. Some arise from natural processes. For example, the light-coloured bands which enclose the Romano-British burial ground at Litlington (30) are of geological origin.

The selection of sites and photographs chosen for the book are inevitably coloured by personal preferences, as well as by the availability of suitable views of particular sites. Sometimes there were no photographs available to illustrate a site whose importance would otherwise make its inclusion essential; at other times, confronted by a wealth of excellent views of a variety of sites illustrating a particular point, sites have been excluded for more idiosyncratic reasons.

Since limitations of scale and cost make it impossible to show all of Cambridgeshire in every period, the reader is invited to generalize from the particular localities shown in each photograph to imagine how the different parts of the county may have looked at different times.

NOTES ON THE ILLUSTRATIONS
(N) denotes the general direction towards which the photograph is viewed, relative to the points of the compass.
* denotes a site which may be accessible to the public. Readers should check with the individual or organization that owns the site to find out if this information is still correct.

Susan Oosthuizen
Great Eversden
October 1995

5 VIEW OVER WHITTLESEY FEN* (N)

This view over Whittlesey Fen encapsulates the geographical context and the history of man's influence on the landscape.

To see it as it was in about 6,000 BC, one must imagine this flat fenland basin blanketed with primeval woodland and inhabited by hunters following elk, deer and wild cattle. As sea-levels rose, and water began to back up along the rivers which ran through the forest from the uplands in the south to the sea in the north, trees and other vegetation along the river banks began to rot and fall into the water, creating small dams and eventually leading to the formation of peat. Meres developed in areas which lay below sea-level, while the areas between sea-level and about 3 metres above sea-level were generally flooded in winter.

These rich fenlands were exploited in a variety of ways: for reeds and sedge, for peat, for wildfowl and fish, and for osiers (rods from coppiced willow). Livestock, particularly cattle, thrived on the rich early hay which grew in spring on the flooded meadows, and became an important part of the farming economy, producing cheese and hides as well as fresh meat on the hoof.

The area shown here was only drained after 1728. It was then divided into fields for those who had invested in the drainage works. The brickworks in the middleground were founded in the mid-nineteenth century as new housing was needed for a rapidly rising population in the nearby towns and villages.

1: BEFORE THE ROMANS

c. 11,000 BC – AD 43

The underlying folds and ridges of the Cambridgeshire landscape present a variety of opportunities for man to exploit as both hunter and farmer. In the southern part of the county, a series of dry chalk ridges each carried a ridgeway throughout (and after) prehistory. Other long-distance routes developed following the course of rivers, generally forming intersections with the ridgeways at significant river crossings. In the west and east the clay uplands tended to remain wooded, as their soils were too heavy for easy farming. The light valley soils of the River Cam and its tributaries, taking upland waters north to join the River Ouse and thence the sea, were the first to be cleared for settlement, which also took place in the broad, flat clay basin north of the River Ouse where rivers are able to move only sluggishly before meeting the sea at the Wash.

In the middle Stone Age or Mesolithic (*c.* 11,000 BC –? *c.* 4,500 BC) the numbers of people in Cambridgeshire began very slowly to increase. The county they inhabited was almost entirely blanketed by the wildwood – primeval woodland of lime, elm, ash and oak – including the densely forested fenland basin which still lay well above sea-level. The Stone Age economy was based on hunting, fishing, and gathering the wild crops of the countryside. Territories developed within easy reach of a base camp, where the weaker members of the group might live semi-permanently while others were away collecting food. For example, hunters slept overnight on Gamlingay Heath, sharpening their stone tools around a small fire before going to search for their quarry of red deer, wild cattle or elk. At a seasonally occupied spring camp at Shippea Hill near March, three or four families returned for many years to trap fish and to hunt animals in woods dominated by pine, with stands of elm, lime and oak.

The period from about 5,000 BC onwards saw two momentous changes in the Cambridgeshire landscape. First, sea-levels began to rise to about their present level and the fenland rivers found it more difficult to disgorge their waters into the sea from the flat lands through which they travelled. The rivers of the natural drainage system began to suffer from partial ponding and back-up of water, as they travelled through the central fenland, and pockets of peat began to form where vegetation became inundated. Trees died and fell into the bog (sometimes preserved as bog-oak), and gradually, as this process repeated itself, the peat spread south towards the fen-edge.

For the next several thousand years, sea-levels rose and fell on either side of the current sea-level: sometimes they were high and much of fenland was covered with lagoons of seawater which laid down layers of silt before the water receded; occasionally, sea-levels were a little lower and people moved into the fenland again.

The second major change was the introduction of farming during the new Stone Age or Neolithic (*c.* 4,500 BC – *c.* 2,500 BC). Widespread deforestation occurred in the uplands at the same time that permanent farms and fields became established. Scattered farmsteads with small fields and droveways for cattle lay centred around thatched and timber-framed houses. Large tracts of land were apparently used for religious purposes, with long barrows built for generations of rulers at Haddenham, Royston and Swaffham Prior, while henges and causewayed camps were constructed at Wilbraham, Melbourn and Maxey.

These trends continued during the Bronze Age (*c.* 2,500 BC – *c.* 700 BC) and Iron Age (*c.* 700 BC – AD 43). As the population grew, so farmsteads were built closer together, until, by the time of the Roman conquest in AD 43, they were often no more than a kilometre or so apart. Fields and their connecting droveways covered the landscape. In the uplands the wildwood came under the axe, until there was perhaps a similar amount of woodland as there is today. The influential continued to be buried in barrows – round rather than long – and, by the end of the Iron Age, some had created large rural estates devolved to tenant farmers. Pressure on resources appears to have led to increasing conflict, and by the middle Iron Age a number of hillforts had been established looking out over the Cam valley or the fen-edge.

The fens only remained relatively empty. They were drier for a time during the middle Bronze Age when several barrow cemeteries were constructed on the skirts of the clay fenland islands. But the waters began to rise again in around 1,000 BC and generally farmers were driven out of the fens until the floods receded again at the beginning of the Roman period.

6 SOHAM MERE* (NE)

As sea-levels rose during the later Bronze Age, a number of shallow lakes, called meres, were formed where water collected in areas which lay below sea-level. Here, the light-coloured mineral bed of the former lake called Soham Mere stands out against the dark of the surrounding organic peat. Chalky water and silt was brought down from the nearby limestone hills by the streams and rivers which flowed into the fen basin. As the area was so flat, the waters flowing through the mere moved only sluggishly, allowing chalk sediments and silt to settle on the bed.

The lake supported a rich multiplicity of fish and wildfowl, until it was drained in the nineteenth century. In the prehistoric period it carried even more exotic species, like pelican and beaver, the bones of which have been found in nearby excavated farmsteads. In the Middle Ages the mere was so important that fishing rights were divided between a number of major manors. The king alone received 3,500 eels a year from Soham Mere in 1086, while Count Alan expected another 1,500. Eels were not the only fish: the medieval *Book of Ely* records that 'there are netted innumerable eels, large water-wolves, even pickerels, perch, roach, burbots, and lampreys which we called water-snakes. It is indeed said by many men that sometimes . . . the royal fish, the sturgeon (is) taken.'

7 RODDON AT LITTLEPORT* (SE)

The light-toned silted-up watercourse of an extinct river, called a roddon, winds its way across the dark fenland peats near Littleport, marking an earlier course of the Little Ouse. The river gradually silted up because its sluggish water was unable to scour the riverbed. The darker line down the middle of the roddon shows where the last stagnant trickles of water allowed the formation of peat as the river gradually became blocked. Nowadays, as the peat has shrunk, so the roddon stands up higher than the peats which it once drained. This process of watercourses becoming blocked and finding new beds was repeated all over the peat fens throughout the prehistoric period, and the roddons of major rivers and their tributaries can be seen from the air throughout the fenland.

Farmers of all periods have preferred to build their houses on the solid silt roddons. The Littleport roddon is no exception. The farmhouses were built after the fens were drained to allow farmers easy access to their new fields, and almost all lie where the hard silt of the roddon meets the easy access of the post-drainage roads, rather than on the surrounding unstable and shrinking peats.

8 PINGO AT THORNEY (S)

A relic of much earlier times can be seen at Thorney. Here, during the Ice Age, a huge lump or lens of ice formed under the old ground surface, fed by water that turned to ice as it reached the frozen layer near the surface. As the water turned to ice, it expanded, and this process continued until a mound of ice was formed, like the 'pingos' in the Canadian arctic. Eventually, when the soil cover slipped off the mound, the ice melted, leaving this characteristic oval depresssion. Its higher outside rim is the light mineral soil which underlies the peat, while the darker interior – where water collected after the fenland basin became flooded – is filled with peat. Most pingos are only a few metres in diameter, but this huge one at Thorney is the only one of its size certainly known in Britain.

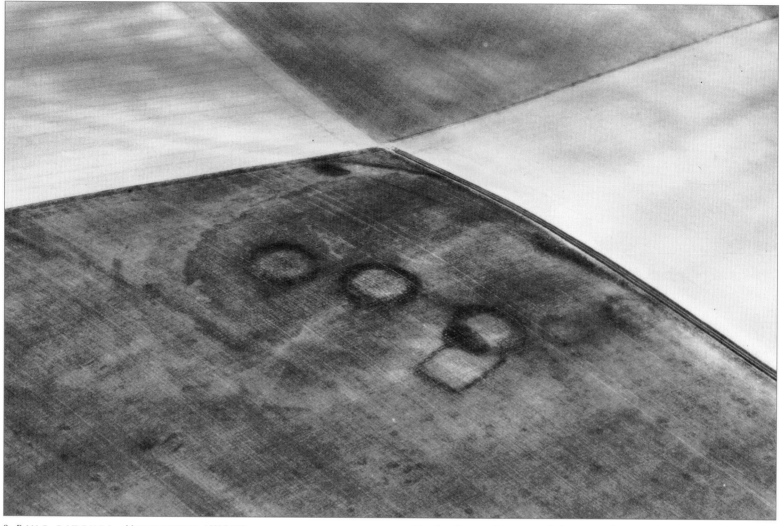

9 RING-DITCHES, MELBOURN (WSW)

Similar circular ditches can be seen from the air all over Cambridgeshire, in the fenland as well as in the chalk uplands to the south and east. They have been found by excavation to be the remains of large ditches which were built to surround round barrows or low mounds during the Bronze Age (*c.* 2,500 BC – 700 BC).

Here at Melbourn they stand near the chalk ridge of the Icknield Way, where travellers would have seen them from a long way off. (In the fens, similar groups were built near waterways.) These barrows were built as burial monuments for prominent people, and were often reused by others over long periods, particularly for cremations. As with other barrows, their siting was carefully planned: not only on high ground in a prominent position, but also near the remains of religious sites from earlier times, in this case almost certainly the religious landscape of Neolithic and Bronze Age barrows still preserved at Therfield Heath. As is common, this group looks like a cemetery where several barrows are clustered together. Recent research suggests that they were built for the leaders of Bronze Age society, and were placed near the frontiers of territories where the spirits of the dead could protect the living from attack by their neighbours. These barrows are sited near the Icknield Way, which has been a territorial boundary for longer than we can calculate.

Like most barrows in Cambridgeshire, these have been ploughed out and can no longer be seen from the ground, although from a bird's-eye view their ring-ditches remain to intrigue us.

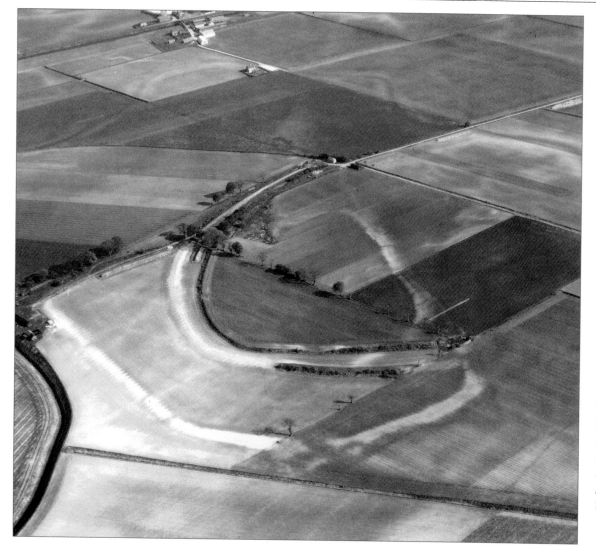

10 STONEA CAMP* (SSE)

This enormous fort on the edge of the fen island at March covers 24 acres and is unusually large and complex. The siting of the fort was carefully considered, and the single ditch and rampart defending the south and west were constructed at the exact point at which the island begins to rise out of the fen. A nearby stream kept the ditches full of water, and the fen marshes offered added security. The fort needed the more elaborate protection of several banks and ditches to the north and east where the ground was higher and drier.

Stonea Camp was built in dense woodland during the Iron Age to protect surrounding communities, which seem to have come here primarily in times of crisis. The area was not used for farming during this period, and perhaps the hillfort offered a degree of safety for Icenian pioneers from the east who began to cultivate the fens as they became drier during the late Iron Age. If this is so, then Stonea was a frontier fort between the *Iceni* in Norfolk and other groups to the west.

The fort appears to have been attacked and partially destroyed in a battle between the Roman army and local people. Occupation ended in a brutal slaughter in which men, women and children were massacred, and might date to AD 47, when it was recorded that Roman legionaries overran a 'rustic earthwork' built in woods in eastern England.

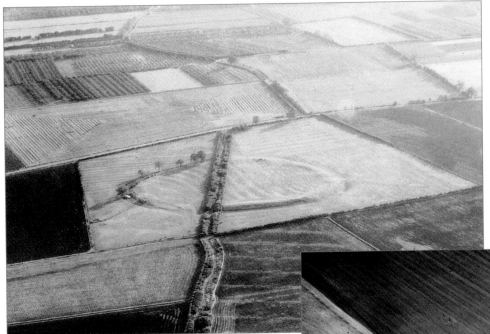

11 BELSARS HILL, WILLINGHAM* (SW)

This is a fascinating example of a hillfort with a single line of defence, looking out over the fen-edge towards possible raiders from the north.

The road crossing the hillfort was called the *Via Regia* (king's road) in the Middle Ages and originally went around the fort. The ridges of medieval ploughing can be seen in the interior of the fort. As the ploughing respects the banks and is not overlain by them, this means that the hillfort was constructed prior to the Middle Ages.

During the Iron Age, defensive works became much more common as the population pressure on the land increased and people needed to protect their territory from outsiders. Several hillforts were constructed in Cambridgeshire, and these vary enormously from those with a single ditch and rampart (univallate) – like this one – to those which have several lines of defence (multivallate).

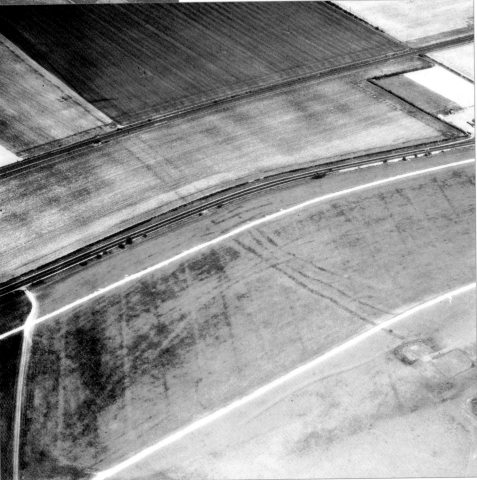

12 MILE DITCHES, ROYSTON* (N)

Near Therfield Heath in Royston, three rather irregular parallel ditches cut across a major prehistoric through route, the Icknield Way. North of the present road (top) they have been ploughed and appear as crop marks; while south of the road, on Therfield Heath, they have been preserved as earthworks and can be seen from the ground by the discerning eye. Similar ditches in Lincolnshire are believed to be part of a larger ritual landscape, linking with barrows and ditches. They may mark prehistoric boundaries.

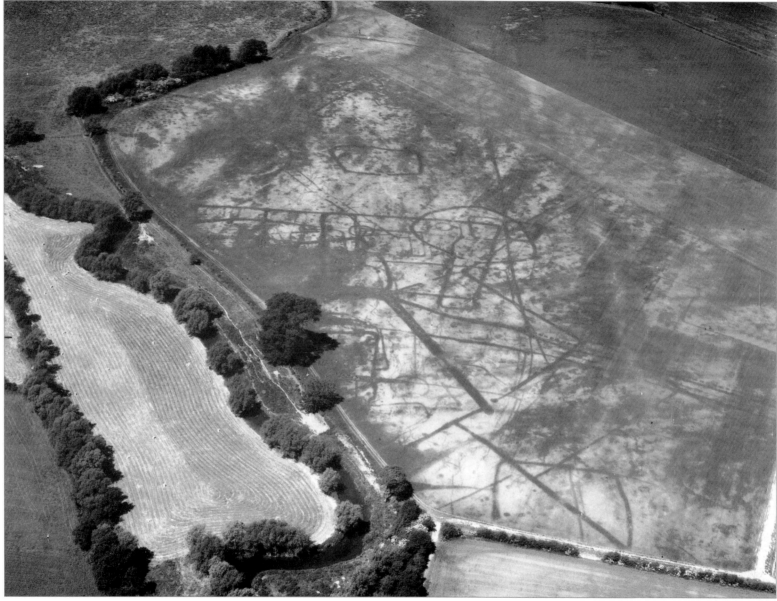

13 IRON AGE SETTLEMENT, GREAT SHELFORD (NNE)

An Iron Age farm has been preserved as crop marks in a riverside field near Great Shelford. The site has been reused over many centuries, which is why there are so many ditches cutting across each other in different directions. The irregular round enclosures may mark the sites of the farmyard at different phases in the farm's life – the farmhouse and outbuildings were circular, thatched and timber-framed, and they cannot be made out from the air. Two parallel ditches marking a droveway lead between the enclosures and the river, and the single-ditched outlines of small, roughly rectangular fields can also be seen. Wheat, barley and peas were grown in these fields; cattle (and sheep) were driven along the droveway to meadows along the river and pasture on higher ground, some of which may have been shared in common with other farmers in the district. The use and reuse of the landscape over thousands of years has resulted in this rather typical jumble of ditches, which often need excavation to work out the sequence in which they were constructed. These small farmsteads were scattered all over a largely cleared landscape, often no more than a couple of hundred yards apart. Many were used for several generations, before the farmstead was moved to another part of the farm. We should see this kind of scattered, shifting hamlet and farmstead as characteristic of settlement in England, particularly during the prehistoric period.

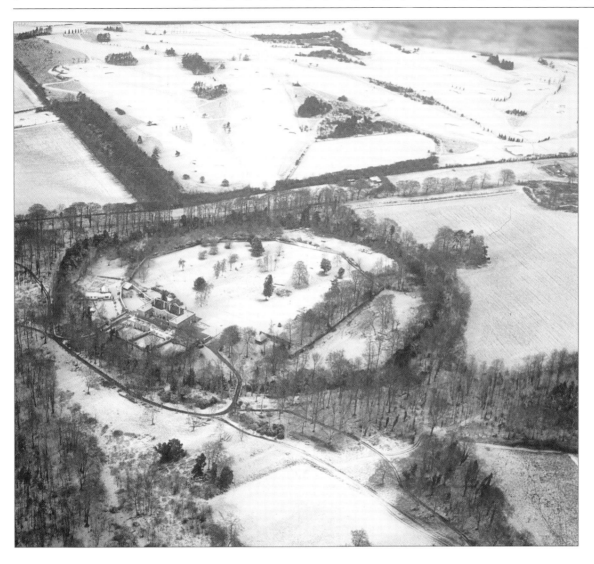

14 IRON AGE HILLFORT, WANDLEBURY* (SW)

Wandlebury is the best known of a number of similar defensive works which were built in Cambridgeshire during the Iron Age. It overlooks the Icknield Way (the main highway from southern England) towards the east and the Cam valley – together with its fords and approaches – to the south and may be one of a ring of forts which ran along the edges of Icenian territory.

When the fort was first constructed in the third century BC, it consisted of a single ditch and rampart. Refurbishment in the late first century BC or early first century AD left the fort much more strongly defended with an outer bank, two concentric ditches separated by a bank, and a final inner bank to defend the interior. The circular defences are marked by trees (planted during the eighteenth century as part of a garden landscape).

Landscaping by Lord Godolphin in the eighteenth century, when a country house was built in the centre of the fort, resulted in the levelling of the two inner banks and the filling in of one of the ditches. Today the site is managed as a public park and nature reserve by the Cambridge Preservation Society.

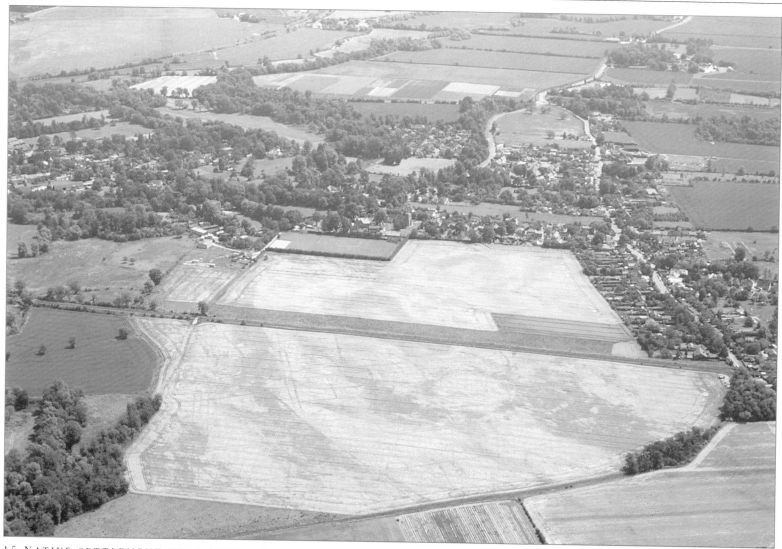

15 NATIVE SETTLEMENT NEAR LITTLE SHELFORD (SE)
Here, the crop marks of ditched droveways are visible, and irregular enclosures of earlier field systems can be seen inside the hedgerows of the modern fields. As some ditches cut across others, the site was probably used and reused over a long period.

The field systems of later periods overlie those of earlier ones. There are a number of reasons why this may have happened. For example, we know that new fields were laid out on an immense scale in the Bronze Age over pre-existing fields and farms; in other cases,

long periods of neglect may have erased earlier signs of land use and farmers clearing the area afresh may have created new fields on a disused site.

This kind of photograph is more useful to archaeologists in indicating the presence of a potential site than in explaining the sequence in which the ditches were cut – something best discovered through excavation. However, the irregularity of the layout and the enclosures suggests that the complex was used in prehistoric rather than later times.

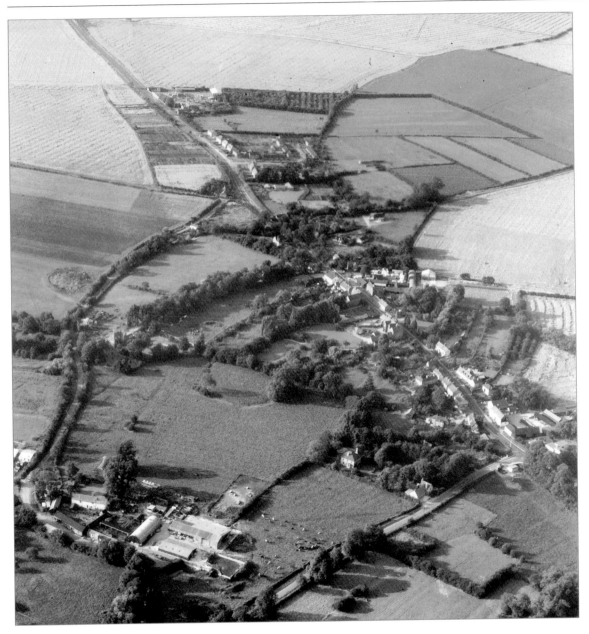

16 PREHISTORIC FIELDS, CAXTON (SSW)

The most prominent feature in this landscape is Ermine Street, the Roman road (running from below centre right to top left). Ermine Street was built fairly soon after the Roman conquest in AD 43 by the legionaries of Legio IX Hispana in order to connect the military bases of southern England with the frontier to the north.

The hedged fields and properties on either side of the road in and near the village are the objects of interest. Careful examination of their stepped boundaries shows that they are rectangles or squares divided into triangles by the road – an indication that they were there before the road was made, and that the lines of these hedges may have been laid out in the pre-Roman centuries.

Their survival need not mean that these fields have been continuously farmed since they were first laid out – they may have suffered from periods of neglect when they lay uncultivated and full of scrub. But farmers clearing the land for farming once again will have found the ditches which first delineated them and will have reused them, thus unwittingly perpetuating a field pattern which pre-dates the Romans.

2: ROMAN CAMBRIDGESHIRE

AD 43 – c. 410

The settled landscape of scattered farmsteads, fields, woods and droveways which had developed over the prehistoric centuries in Cambridgeshire probably remained little changed during much of the Roman period. In the early days after the British surrender at Colchester (*Camulodunum*) in AD 43 the Roman army marched north and west from Colchester to secure the new province. They used local roads and built their forts along natural boundaries: in the area in question, forts were built along the River Ouse at God-manchester and Cambridge, looking towards the major fortress at Longthorpe, near Peterborough, for orders. There may have been some initial local resistance, perhaps at Stonea Camp, but the region was soon peaceable enough except for the brief episode of Boudicca's rebellion in AD 61.

The incorporation of Britain into the Empire had long-term commercial benefits for the country as it became part of a wide-ranging trade network. Good transport and markets were essential to gain the maximum benefits, and there is some evidence of local specialization, which is also a feature of a sophisticated economy.

These new economic factors were reflected in the formalization of two landscape features which had only been hinted at in prehistoric Britain. First, long-distance trackways were straightened and metalled – and in some cases new long-distance roads were built to connect Roman administrative centres. Second, towns were founded as part of the colonizing process to provide administrative and market centres, which helped to seduce the aristocracy into cooperation with Rome.

The Roman road, running straight for miles with only minor changes of alignments, is a familiar feature of the English landscape. Initially these were military roads like Ermine Street, built for the army across the countryside with no regard for the existing landscape and intended to provide good support and supply routes, and quick access to areas of unrest. The Fen Causeway, for example, was built across fenland to extend military control over the area east of Longthorpe after the Boudiccan revolt in AD 61. But by the early second century AD, roads were built as much for commercial reasons. For instance, the old riverside route between Cambridge and Huntingdon was replaced by a straight

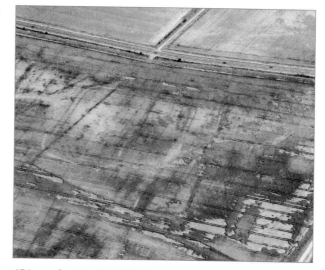

17 Roman fort, Grandford (ENE). The northern side of the fort can be seen as a double ditch, with its characteristic rounded corners at the top and bottom.

road, while an ancient trackway leading east towards Colchester was straightened and metalled. Minor prehistoric droveways and local roads continued to be used by local people, and new roads developed in the fens.

Towns grew up around the small forts at Cambridge (*Durolipons*) and Godmanchester (*Durovigitum*), both at fords over major rivers. Eventually the forts were dismantled, but the towns continued to thrive. Cambridge was replanned from scratch in the early second century, while an up to date hotel complex, complete with baths and temples, was constructed at Godmanchester. In the early fourth century the towns were walled, and the line of these walls is often the most visible relic of urban life.

The Iron Age aristocracy adopted the ways of Rome with enthusiasm, participating in town councils and rebuilding their houses on their country estates in the contemporary villa style. Classical gardens were created and often planted to include some new species – the baytree and sweet chestnut, for example. Yet in many ways the Romano-British retained their own culture – the cemetery barrows at Bartlow and Litlington were a British rather than a Roman custom. Tenant farmers and labourers may also have seen little immediate change: they still paid their rents to the estate owner; fields, lanes and farmsteads continued in use; and woodlands and pastures were still communally managed and controlled. Different kinds of crockery and dress, and a smattering of Latin in the Celtic, were superficial rather than deep-seated changes. Economic change was more apparent and there is some evidence that the upland estates in Cambridgeshire began to specialize in the production of grain, becoming less self-sufficient than they had been.

The fens, where water levels had fallen, became an imperial estate, managed from an impressive stone-built complex at Stonea. Large-scale flood prevention was carried out by digging canals like the Car Dyke or the north-east Cambridgeshire lodes, and tenant livestock farmers were brought in to colonize 45 acre farms. Field ditches and droveways, as well as the house platforms and allotments of these settlers, survived in pasture in many parts of the fens until recently when they came under the plough.

18 ERMINE STREET – ROMAN ROAD* (NNW)

This view is near Longstowe and looks along the line of Ermine Street, one of Britain's major Roman roads. Its original surface is now hidden from view under (and sometimes along) the modern road. The road ran straight over the landscape for mile upon mile in the 'classically straight Roman alignment'. The surveyors were careful, none the less, to take advantage of the landscape – passing over the ridge at Wimpole at its lowest point, and making use of already existing fords at Arrington and Godmanchester.

This was the first Roman road to be built in the region, connecting it with London to the south and, eventually, Lincoln and the Humber to the north. The Roman surveyors, working from south to north, laid the road in sections of up to several miles in length. Small adjustments and changes of direction were achieved at the points where sections join. The road was paved with successive layers of rammed chalk and gravel, which raised the 4 metre wide path up to 1 metre above ground level, and was bordered by wide verges between ditches.

It is followed to a large extent by the modern road and appears to have been almost continuously in use from the time of its construction.

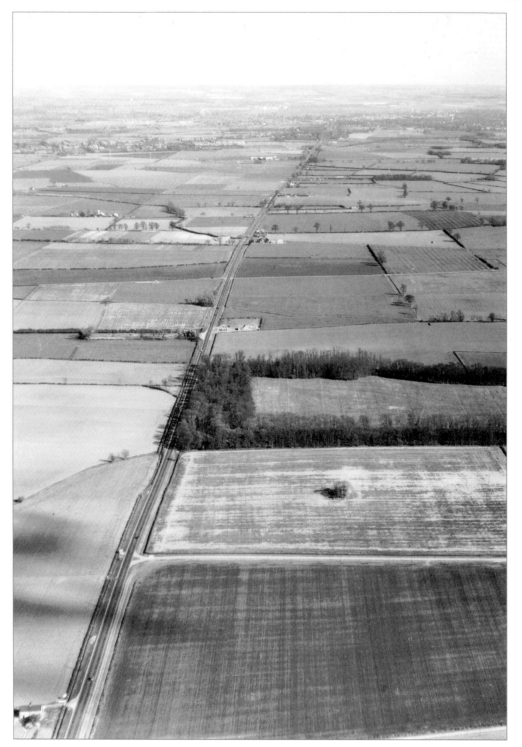

19 'VIA DEVANA' – ROMAN ROAD* (SE)

The characteristic straightness of this road for mile after mile between Cambridge and Godmanchester immediately identifies its Roman character. It is also a parish boundary for most of its length – another indication of its origins. The road was built to carry traffic along the fen-edge between the two Roman towns at Cambridge and Godmanchester, replacing an earlier prehistoric route which had travelled more circuitously as it meandered parallel to the banks of the River Ouse. Built in the early second century AD, the road was constructed in straight lengths with small changes of direction at their junctions.

This road is sometimes called the 'Via Devana'. In fact the name has no Roman connection and was coined in the eighteenth century by Charles Mason, then Professor of Geography at the University of Cambridge.

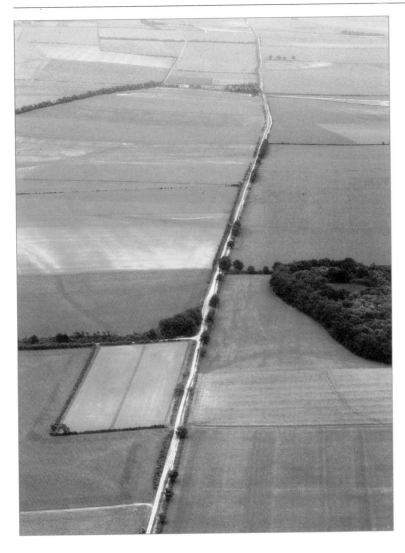

20 WOOL STREET – ROMAN ROAD* (SE)

Wool Street, which takes its name from the wolves which roamed it in Saxon times, follows a characteristically straight Roman alignment out from Cambridge to the east. Unlike most other major Roman roads in the county, it still survives unconcealed by its modern successor: the present road to Colchester does not follow the Roman road but runs a little way to the south. It was a prehistoric trackway before the Romans came – they only managed to modernize it as far as Horseheath, and there the prehistoric trackway can also be seen.

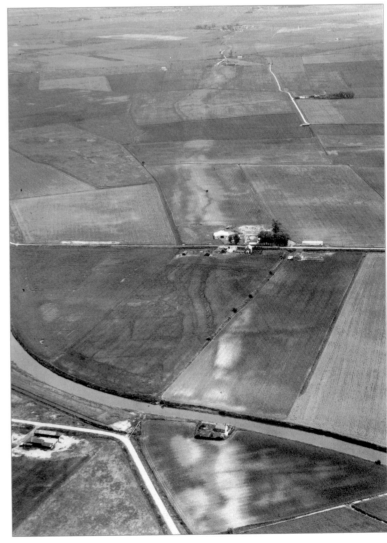

21 THE FEN CAUSEWAY (E)

The Fen Causeway runs east (from bottom to top) as a blotchy, winding, thick white line crossing the peat fens to connect the legionary fortress at Longthorpe near Peterborough with the Norfolk mainland at Denver.

This is a remarkable route, initially made up of roadways across the fen islands, which were linked by stretches of canal across the inundated peat fens. It is one of the canalized sections that can be seen here, not quite as straight as a conventional road because the engineers used little creeks and streams to make the canal-digging easier.

The canals became silted up in severe floods in the mid-third century AD, which explains why the causeway survives as white silt in the dark peatlands. When it was rebuilt in c. AD 300, the engineers used the banks of the silted up canals to carry the road, so it was quite late in its life that it became a true road throughout.

22 ROMAN CAMBRIDGE* (S)

The River Cam (top left) lies south of the site of *Durolipons*, the Roman town at Cambridge. The road to Godmanchester crosses the town from north to south (bottom right to top left). The south-western road from Arrington heads straight towards the centre of the Roman town (along Lady Margaret Road), although it has been stopped by later developments just before the junction with the Godmanchester road. The line of a fourth road, from Ely in the north-east, is not clear from the air.

The earliest Roman settlement, built soon after the conquest, was a small fort west of and aligned on the Godmanchester road. It was swept away in the early second century and replaced by a planned town, again using the Godmanchester road as the baseline for the alignment.

The northern and western line of the early fourth-century walls has been preserved by the road (Mount Pleasant), which ran outside them. It can be seen leaving the Godmanchester road (on the right, just south of a modern road which joins the Godmanchester road on the east), and after a short straight stretch curving round to go south towards the river. The north-eastern defences crossed the Godmanchester road at the junction with Mount Pleasant, and after a short straight section also curved round to the south, more or less followed by the border seen here between residential and administrative buildings. The southern line is not visible from the air, but it has been found in excavations.

23 ROMAN GODMANCHESTER* (NE)

The Roman town at Godmanchester (possibly called *Durovigitum*) originally grew up outside a small garrison fort which was built soon after the conquest in AD 43. Within a few years the fort was guarding the crossing of the new Roman road, Ermine Street, which initially ran between London and Lincoln, and the River Ouse. Although the fort was soon abandoned, a government staging-post developed at Godmanchester with an impressive *mansio* (hotel) for official travellers, complete with baths and temples. The settlement grew up along Ermine Street and was walled during the third century. Although the walls have almost disappeared, the roads which ran along them have not, and it is these which outline the Roman town from the air.

The late Roman town was polygonal in shape and outlined by three walls. The first wall ran along the far side of the road which crosses the lower part of this view (left to right) along the water's edge. The second wall lay along the right side of the road which meets the first road on the left and then travels diagonally out towards the top of this view. The two were linked by a third wall, also now shown by the curving road which ran alongside it. It began where the first road turns sharply towards the top of the picture at the far right edge. From that corner the walls were built in three straight sections of differing alignments to meet the second road near the centre of the picture, creating a five-sided figure to define the town.

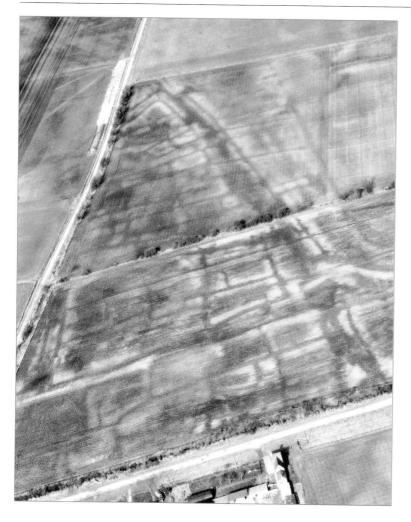

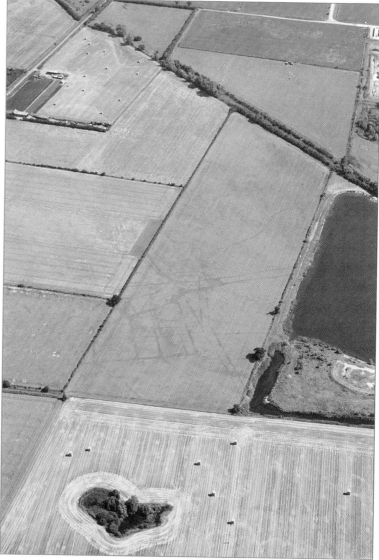

24 ROMANO-BRITISH SETTLEMENT NEAR MARCH (NE)

The ditches of this settlement have become filled first with light-coloured silt and then with dark-coloured peat, which show up well on this photograph after ploughing. A Romano-British canal crosses the photograph from top left to bottom right. It was dug to aid flood prevention in the new imperial estate, and it connected with a system of rivers and canals, including the Fen Causeway. The farmsteads and fields of this small settlement can be seen leading away from the canal to the left. The Fen Causeway crosses from right to left as a band of white silt, and the metalling of the rebuilt early fourth-century road cuts across the (by now silted) canal. The site was preserved as upstanding earthworks until 1949–1956, when the fields in which they stood were bulldozed and then ploughed.

25 NATIVE SETTLEMENT NEAR COTTENHAM (NE)

This ploughed-out settlement lies under the modern field system next to the Car Dyke, a canal cut during the Roman period as a flood prevention measure and also used for transport. This is the double-hedged feature which runs diagonally across from east to north. A Romano-British droveway, defined by the ditches which lie on either side of it, cuts across the modern field at an angle from right to left, widening out to a green on the left. Below it, and aligned on it, are the regular ditched fields – some subdivided – of this small farming settlement, while another droveway leaves the first to head towards the bottom right of the modern field.

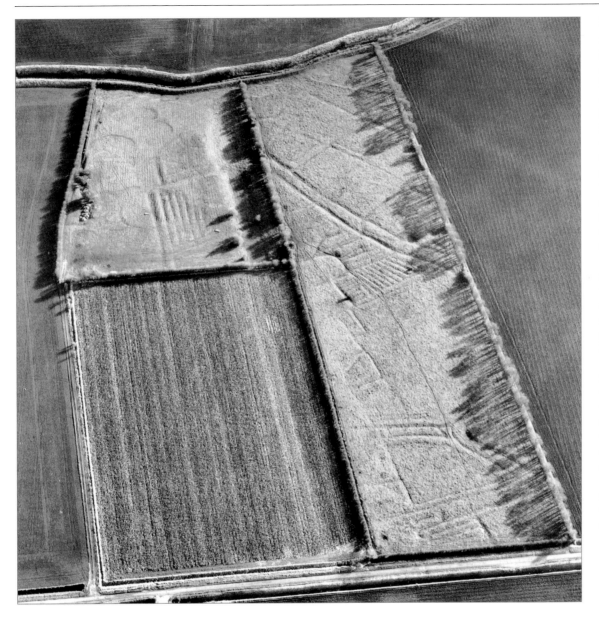

26 ROMANO-BRITISH SETTLEMENT, COTTENHAM (SE)

Part of a large Romano-British farming village has been preserved in the grass of a low fen island near Cottenham. The earthworks can be seen in two fields, one long and one short. The division between the fields runs along a wide depression which marks the line of a Roman canal, the Car Dyke, which was dug in the early second century to lead the waters of Waterbeach and Cottenham into the old course of the River Ouse at Earith. The scale of this canal can be judged by comparing the width of the dyke with that of the road and trees.

A straight, ditched droveway leads away from the right of the Car Dyke at an angle at the top of the field, with small rectangular fields aligned on and above it. As the dyke cuts across the line of this droveway and fields, it was probably dug after they were laid out.

From the middle to the bottom of the field, house platforms line the right bank of the dyke, with lanes and droves leading off the dyke to the right at right angles. It looks as if a small trading settlement grew up here on farmland after the dyke was built, with another development to the left of the dyke overlying earlier Romano-British fields. The 'corrugated' areas are the remains of intensive vegetable farming where the soil was mounded up in short straight lines — the settlement's allotments.

27 REACH LODE* (NW)

The right-hand waterway here at Reach, heading straight towards the bottom of the photograph and the fen-edge, is an artificial canal or 'lode'. It was cut across the natural drainage pattern by Roman engineers in the second century AD. One of several similar canals linking the north-east Cambridgeshire fen-edge with the River Cam, it was designed to prevent flooding of the undrained peat fenlands (which provided excellent grazing and reed or grass crops). Once cut, of course, the lode was used for transport as well as for drainage. It is believed to be of Roman construction, partly because many Roman finds have been made along it, but also because the Saxon Devil's Dyke is deliberately aligned on the lode. (The left-hand canal is a relief channel which was cut in the seventeenth century.)

28 REACH VILLA (SE)

This villa lies on ground which slopes gently down towards the fen-edge. It is a corridor villa, the main block of which is 25 feet deep and at least 130 feet wide. Two wings project forward from the main building. Excavation has revealed floor and roof tiles, and evidence of underfloor heating. The rooms were painted in bands of red, blue and green decorated with paintings of flowers and plants. Like the other south Cambridgeshire villas, it was probably built for a Romano-British family, descended from late Iron Age aristocracy, who owned a large estate in the area.

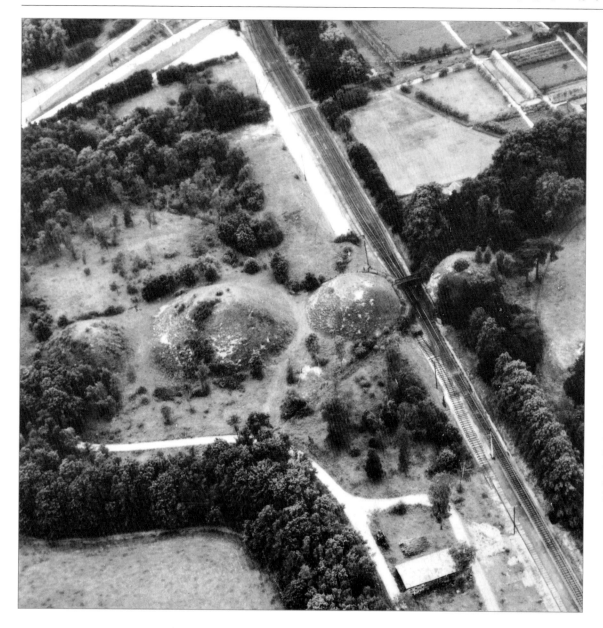

29 BARTLOW HILLS* (WNW)

These four large burial mounds, which used to lie just over the Cambridgeshire county boundary in Essex but have recently been reunited with the Cambridgeshire parish of Bartlow, are all that remain of a group of eight which existed until the sixteenth century. The largest mound stood 13.7 metres high and was 44 metres in diameter, but this one no longer exists. The finest set of Romano-British burial mounds in Europe, this cemetery served at least three generations of owners of an estate centred on a large villa in Bartlow. Of course, barrow burials began in Britain long before the Roman conquest. The Iron Age aristocracy who retained their estates and political position in Roman Britain no doubt also maintained some local customs and wished to be buried in the manner of their ancestors. There are other Romano-British barrows in Cambridgeshire, but none as fine as these.

When the hills were excavated (some might say vandalized) between 1815 and 1840, wooden chests containing cremations were found in chambers at their centres. They contained cremated remains accompanied by food to sustain the deceased in his or her journey to the underworld, as well as boughs of box (a symbol of everlasting life) and lamps which had been lit before the chest was closed.

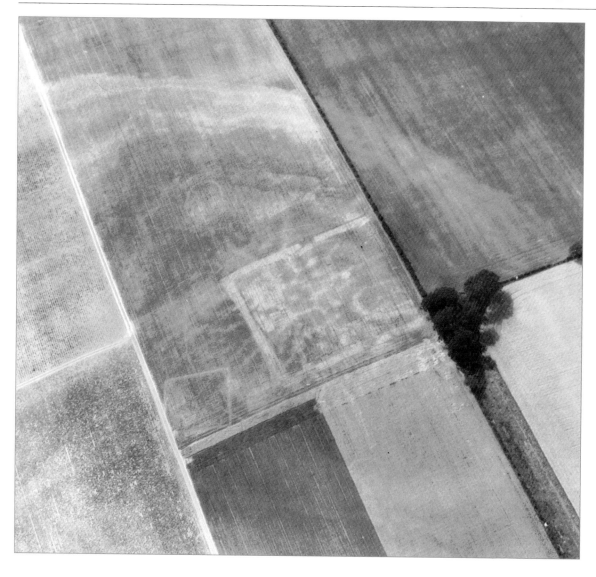

30 ROMANO-BRITISH CEMETERY, LITLINGTON (W)

Limlow Hill, near Litlington, is a small hill lying just south of the Icknield Way. On its summit the remains of a rectangular enclosure can be seen cut into the chalk (with a slighter square enclosure nearby).

The main enclosure consisted of a flat-bottomed ditch dug in the late second century AD around an area 64 metres square. It was a substantial earthwork about 7 metres wide and nearly 2 metres deep which surrounded a Romano-British barrow, which was destroyed in 1888. The barrow was probably built with the upcast from the ditch in alternating layers of chalk and turf, creating a pleasing pattern if it remained unturfed. It is recorded as standing up to 5.5 metres high and more than 25 metres across. It probably contained a burial similar to those at Bartlow Hills. Around the barrow lay a small ditch with a low external bank.

Although most of the white marks within the enclosure are geological in origin, some elongated rectangular marks can be seen in and around the enclosure. They are too large to be graves, but may be associated with burials as skeletons are recorded as being found near the barrow in 1836. Perhaps the hill was used as a cemetery for several generations before the barrow was built. The most likely candidates for its construction and use are the owners of a large villa estate centred on an imposing house at Litlington, a mile away to the north.

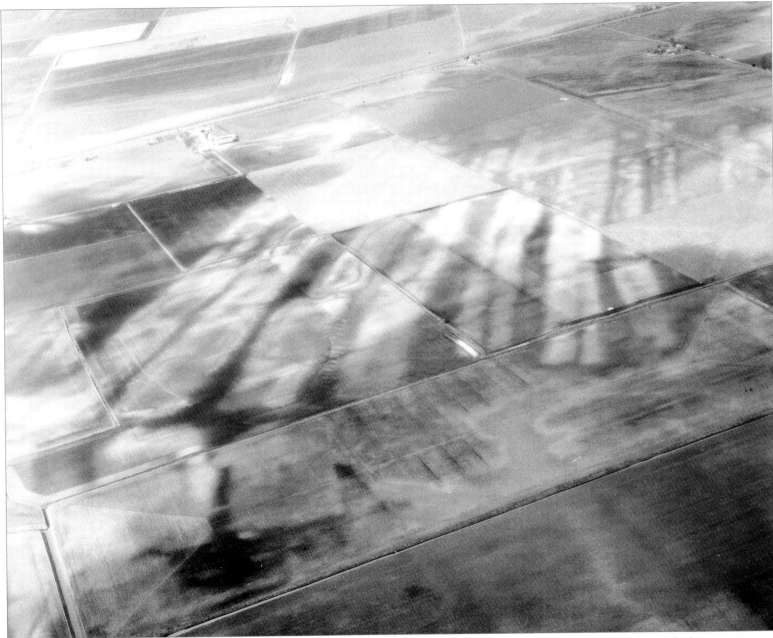

31 ROMANO-BRITISH TURBARIES, UPWELL (NW)
These long rectangular features in the peat fens near Upwell are the remains of Romano-British peat diggings or 'turbaries'. The dark bands are the peat banks which were left between the long diggings as the peat was extracted; the diggings themselves became filled with coarse light-coloured silt during the major floods which inundated the fenland for two generations in the mid-third century AD.

Since the fens were drained after the mid-seventeenth century, the peat has shrunk and today the silt filling these early turbaries stands up in long ridges of up to 2 metres higher than the shrunken peat banks beside and between them, making them quite readily visible from the ground in some places.

32 THE DEVIL'S DYKE*
(SE)

The Devil's Dyke is a formidable earthwork. It runs straight for 7½ miles across the chalk ridge of the Icknield Way from the fen-edge at Reach to the high wooded claylands at Woodditton. Its massive 70 foot wide bank, which stands up to 18 feet above ground level, and imposing 17 foot deep ditch, are poised to repel an attack from the south-west. The dyke was built in one enormous effort and never refurbished, so it is likely the threat in response to which it was constructed was only short-term.

What little archaeological evidence there is suggests that the dyke was built between about AD 400 and 600 to defend the early Saxon kingdom of East Anglia from incursions from the south, and that it acted as part of the frontier between the East Angles and their neighbours to the west and south. To this day the dyke is the boundary between the diocese of Norwich in the north and that of Ely to the south, fossilizing mid-Saxon administrative arrangements.

There are three other similar dykes in Cambridgeshire, although the Devil's Dyke is the most imposing: the Fleam Dyke (between Fen Ditton and Balsham), the Pampisford Ditch (between Pampisford and Great Abington) and the Heydon Ditch (between Fowlmere and Heydon). They all run from the fen-edge to dense woodland, they all cut across the Icknield Way, and they all face in the same direction. Whatever the threat from the south-west, the Cambridgeshire dykes suggest that it was a severe one.

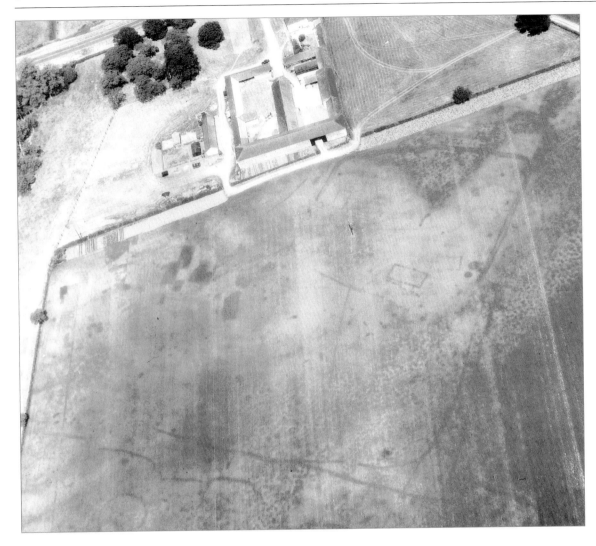

33 EARLY SAXON SETTLEMENT, HARSTON (SE)

The rare remains of an early Saxon farmstead dating to the same period as the Devil's Dyke lie revealed by marks in a ripening cereal crop. The rectangular farmhouse is on the right. Its walls were made of planks of wood set in a trench, and there was a door in the middle of each long wall. The row of dots along one long side of the house may have been made by a line of posts which supported a veranda. The farmhouse lies within a ditched enclosure, where the remains of other buildings – possibly farmhouses of other periods – can be made out. The ditches of fields and of a trackway lie outside the farmstead.

On the left is a group of dark rectangles. These are almost certainly the remains of *grubenhäuser* – buildings whose floor areas were dug out to a depth of up to 18 inches. Evidence from West Stow in Suffolk suggests that these 'cellars' were boarded over. The rest of the structure was built less solidly than the farmhouse, on a timber frame. The buildings probably comprised the workshops and storerooms of the farm, where weaving and other similar activities were carried out.

Economic recession and political instability in the fifth and sixth centuries AD meant that farmers were forced to become self-sufficient, as manufactured goods became unavailable, and local architecture too reverted to using local materials.

3: SAXON CAMBRIDGESHIRE

c. AD 410 – 1066

The withdrawal of Roman administration from Britain in about AD 410 was not perceived as abandonment of the province. Britain, with a population of around 5 million, was expected to remain a self-governing part of the Empire using Germanic mercenaries to augment its own military defences. Saxon burials in Cambridge date from about AD 350 onwards, suggesting that the use of mercenaries was a familiar strategy, and that some may have settled in Britain before 410.

The fifth century saw a series of catastrophes which cut to the heart of prosperous Britain. The economic depression which had affected towns and estates in the fourth century worsened. Trade and markets failed, coinage went out of use and towns were abandoned as they became irrelevant to the needs of local people – by 672, Cambridge was reported as being 'a small ruined town by the Granta (Cam)'. Estates were unable to find markets for their produce – the fine villas of their owners fell into disrepair, and in some cases the outlying parts of estates went out of cultivation. Farmers were forced to become self-sufficient.

Economic anarchy was reflected, as so often happens, in political anarchy as the province descended into civil war with local warlords each trying to establish his own power base. The Cambridgeshire dykes were hastily built across the Icknield Way by the early East Anglian kings against a threat from the south-west.

The population fell dramatically – perhaps as a result of a combination of malnutrition, civil war and illness – and large tracts of landscape were abandoned. The line of the Roman road in Barton, for example, was lost in regenerated woodland, while on the high claylands, trees replaced farms and fields.

Into this decaying landscape came a small number of Germanic settlers – some estimates suggest about ten thousand altogether between AD 400 and 600 – who settled alongside the surviving Romano-British farmers on the easier soils along rivers and valleys, sometimes within the remnants of embattled estates.

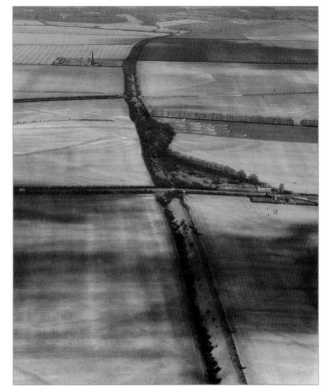

34 The Fleam Dyke* (NW) is another early Saxon earthwork which cuts across the chalk heathland of the Icknield Way.

New styles of wooden architecture emerged as Romano-British technology of brick, glass and tile became irrelevant in these new circumstances, and an example of a farmstead of this period can be seen at Harston.

By AD 600 a number of small kingdoms had emerged in England. The River Cam became the frontier between East Anglia (controlling Norfolk and Suffolk) and Mercia (in the Midlands) for the next three hundred years. Slowly the region became more peaceable. A town was once more established at Cambridge. Monasteries were founded on the fen islands. By about AD 800 the population had grown sufficiently for farmers to start clearing woodland for new settlements as at Kingston – a process which continued well into the Middle Ages – and new estates developed, sometimes on the sites of the old.

In 870 the area was conquered by the Danes and until 917 it fell within the Danelaw, an autonomous region of England under Danish rule. The outlines of trading settlements of this period can still be recognized at Cambridge and Godmanchester. Edward the Elder recaptured Cambridgeshire for the English in 917. He redistributed estates dispossessed by the Danes among the members of his court, created the county of Cambridgeshire straddling the ancient frontier along the River Cam and built a new trading suburb at Cambridge.

In the countryside there was widespread replanning of the landscape between about AD 917 and 1150 as the scattered farms and hamlets which had evolved over the past four thousand years were swept away. Estate owners laid out planned villages like Witchford and Dry Drayton. The small rectangular fields of the dispersed farmsteads were amalgamated into large communally farmed fields divided into strips; although in many cases it seems that the common pastures and woodland which had been developed over the previous centuries were retained in the new planned landscape, as at Whaddon and Kingston.

By 1086 the population had recovered to reach between 1½ and 3 million – about half what it had been in 400.

35 BARRINGTON WATERMILL (ENE)

Watermills have been known in Britain since the Roman period, and a mid-Saxon example has been excavated at Tamworth in Staffordshire. Many watermills were mentioned in the Cambridgeshire Domesday Book in 1086, which suggests that they and the channels which fed them were constructed during the Saxon period.

This watermill at Barrington is one of three documented in the parish in 1086. The River Cam flows in an easterly direction (bottom to top). Its natural meandering course has been straightened to create the best possible gradient for the mill, which is the building which lies over the stream. A channel leads off from the river on the right, rejoining it further up and creating a triangular island. This channel was dug to carry excess water away from the river when the water was high, thereby protecting the mill against flood damage. The millpool below the mill can be seen just above the millhouse.

Although the millhouse and millwheel have been repaired and rebuilt many times over the centuries since the first mill was constructed here, the initial straightening of the river, together with the banks which kept the river within its artificial course, and the digging out of the overflow channel are almost certainly Saxon work.

This watermill became known as Bolbeck Mill during the Middle Ages, from its manorial owner, and remained in use until *c.* 1930.

36 KINGSTON WOOD FARM (SE)

The heavy clay uplands of west and east Cambridgeshire were colonized and cleared or assarted by small groups of farmers from *c.* AD 800 onwards. This tiny settlement at Kingston Wood Farm is a relic of this process and lies among fields cleared from the woods which still surround it.

The circular moat round the farmstead may be Saxon in origin, although perhaps 200 years later than the initial small settlement here. Medieval moats tend to be more regular or geometric in shape.

37 THE COMMON, WHADDON* (N)

The long triangle of land at Whaddon (lying at the bottom of the photograph with its apex on the left and its base on the right) is typical of the funnels through which cattle passed on their way to and from the common pastures. When the cows came home they were controlled by their passage through the bottleneck on the left.

A huge common, which was shared between the people of Whaddon and of Meldreth, lay on the right. Its northern limit is defined by a stream which flows along the top of the funnel; its western (left) boundary has been fossilized by the field boundaries which continue the line of the road cutting across the base of the funnel. Building along the edges of the funnel and the common began in the Middle Ages. The common was created by AD 800 at the latest, and may be considerably older.

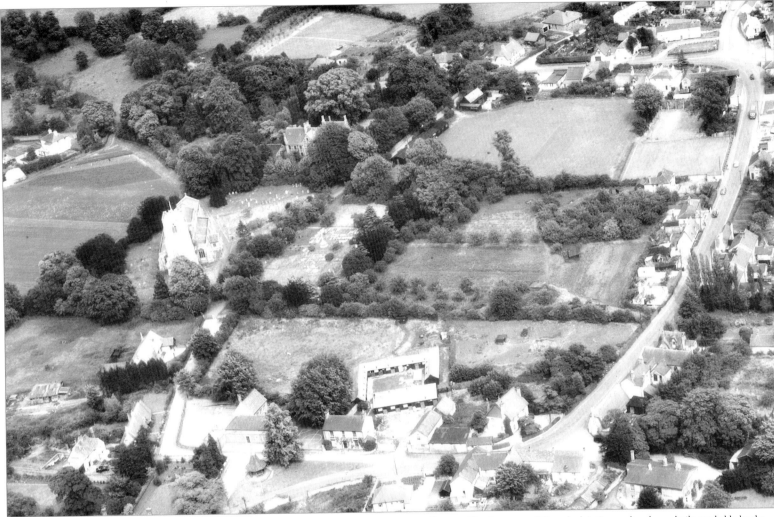

38 RELIC OF A MID-SAXON FARMSTEAD, BALSHAM* (E)

The land south of Balsham church is enclosed by a curving road. Where the road reaches the top and bottom of the photograph, it bends to the left to take a northerly course so that it entirely surrounds a large block of land around the church. The manor house once stood in the clump of trees south (right) of the church, within the line of the road. The road enclosed all of the land around the church and manor.

In 1615 the block of land thus enclosed was owned only by the manor and the church. As the church had once belonged to the manor, this means that the whole block was originally owned by the manor. When the late Saxon church was built, probably by the lord of the manor, he had, entirely conventionally, endowed the church with a part of his home farm.

The curving line of the road as it surrounds the manor and church, together with the rounded corners of the properties within the roads, suggest that the road had fossilized the line of a substantial fence or hedge around a mid-Saxon farmstead of c. AD 800. Similar farmsteads have been recognized in Suffolk, often on the edge of a green or common. The corresponding land in Balsham lay north of the church.

39 SAXON GREEN, HASLINGFIELD* (NNE)

There is little evidence to support the belief that 'the Saxons laid out greens and built their villages around them'. However, the three enormous greens or commons in the contiguous parishes of Haslingfield, Harlton and Barrington are possible exceptions to this rule.

The curving outer ring road at Haslingfield encloses a huge oval tract of land. Historical evidence suggests that much of this land was common until the last few hundred years, with the church inserted uneasily along its southern edge. In the sixteenth century the central section of the green was enclosed for a new manor house and park, possibly on the site of a medieval manor. Older houses in the south-western (bottom)

section of the common along a road running between the church and the manor indicate medieval and later encroachment. Further encroachment occurred around the perimeter of the green, as can be seen from some post-medieval houses and plenty of modern ones, culminating in the twentieth-century estates, the blind curving roads of which can be seen around the north-eastern (top) section.

The date of this green is problematic. The main Romano-British settlement in the parish lay some distance away to the north-east near the river. Other evidence suggests that the new Saxon settlements lay further west and south, nearer – but not on – the newly laid-out green. Late Saxon finds have been made near this common, although the sparcity of early finds may be due to the fact that much land is hidden under houses and gardens.

40 BARRINGTON GREEN* (SSW)

This green, in the neighbouring parish to Haslingfield, is one of the largest village commons to survive in England. The outlines of its original oval extent can still be made out by looking at the back boundaries of the properties which have encroached along its edges. The church has been inserted on the north of the common, placed rather tentatively on the edge, and this probably represents a fairly early encroachment.

In the seventeenth century, a block of houses was built well into the western boundary of the green, and their lime-washed walls and thatched roofs make a pretty sight, despite the fact that at the time they probably looked like a modern estate. The stream still runs through the common and is a reminder of one of the primary purposes of greens: the necessity to provide water and pasture for the village livestock, particularly the cattle. Ponds or streams are virtually defining characteristics of common land, and the edges of greens were commonly ditched to prevent animals from straying.

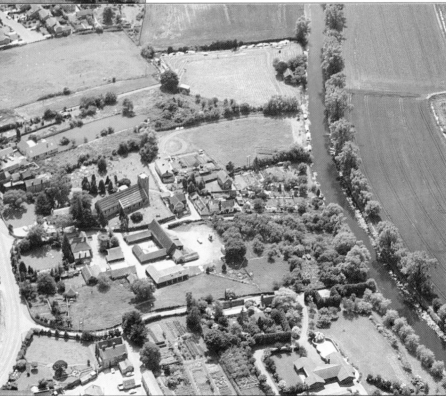

41 PLANNED VILLAGE, WITCHFORD* (E)

This is an excellent example of a planned village. Looking east (up) towards the manor, on the other side of the river crossing, village houses are set out on either side of the main street.

Those on the southern side of the road are probably part of the planned settlement. They share a common straight back boundary and are of a common width – the wider gardens were created by amalgamating two or more properties. These two features are unlikely to have arisen by accident, and are evidence for planning. The irregularly shaped properties on the northern side of the road appear to have been added piecemeal over many years.

As the church site is an integral part of the plan, the settlement probably dates to around AD 970, when Witchford was given to the Abbey at Ely.

42 PLANNED VILLAGE, HORNINGSEA* (S)

Horningsea contains one of the earliest churches in Cambridgeshire. Said to have been a small monastery belonging to the Abbey of Ely in the ninth century and later burned by the Danes in 870, it was rebuilt by the abbey in the tenth century.

Two parallel lanes pass on either side of the church, leading down to the River Cam. There each lane once ended in a small quay or hythe, where traders could load and offload their goods and where local people could land fen and farm produce. Few old properties survive to give us any detail of the original village plan. The regular street pattern aligned on the river, which incorporates the church, is our main source of evidence here for village planning.

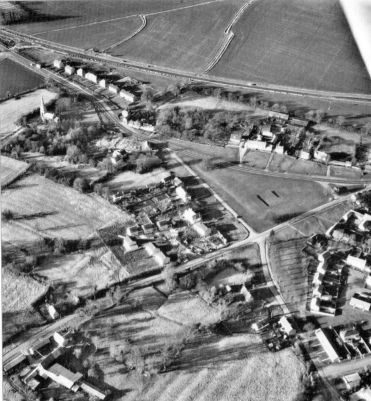

43 LATE SAXON GREEN AND VILLAGE, ELTISLEY* (NW)

Eltisley lies on the three sides of a triangular green. The church stands on the left at the apex of the triangle, and there is a moated medieval site in the centre of its base. Although modern roads cut across the green, making it seem smaller, the line of the house frontages gives a better idea of its earlier extent.

The properties along the northern (top) edge of the green appear to have been laid out as part of a planned settlement during the Middle Ages. Some of the houses are medieval, and all of the properties are of a similar width (or multiples of that width), sharing a common back boundary. The back boundaries of all the houses may represent the green's original limit, in which case all of the buildings are encroachments – some planned; some piecemeal.

44 PLANNED VILLAGE, DRY DRAYTON* (NW)

The languid S-shaped road which curves its way through Dry Drayton was built in the 1960s and should be ignored for the purposes of this photograph. The regular underlying pattern of roads and lanes is that of a geometric grid, evidence for village planning. The village was almost certainly laid out like this during the mid-twelfth century, when documentary evidence shows that medieval fields (now swept away) were surveyed and laid out across the parish, to replace an earlier field pattern, almost certainly of dispersed farmsteads and hamlets. In the north-west (top) a funnel-shaped green can be seen, leading away to the good grazing offered by low-lying land on the fen-edge to the north.

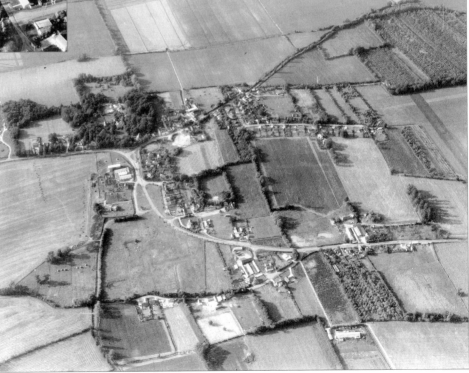

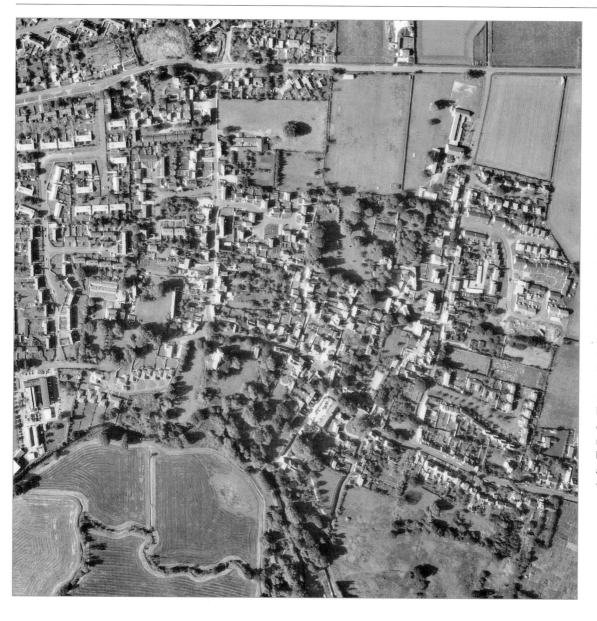

45 POLYFOCAL VILLAGE, DUXFORD* (W)

The River Cam and its tributary streams run along the eastern (bottom) edge of the photograph, and a riverside road mirrors its course from north to south (right to left). Leading away from the river and the riverside road, two straight roads run west (upwards). These were once the main streets of two separate settlements, each with its own church, which have grown together to form one village: two foci have created a polyfocal village.

Planned properties lie along the southern side of the southern village street. The church, Duxford St Peter, stands just east of the junction between the street and the riverside road, between the junction and the river. The regular property boundaries on the northern side of the northern settlement's main street are also visible. This settlement's church – Duxford St John – stands on the southern (left) side of the main street, just north of a small green.

This green is all that remains of a much larger piece of open land which once lay between these two high streets. Over the centuries, people have built houses on it, nibbling away at it, and the irregular boundaries and lanes which accreted on it are visible from the air. It is this irregularity which indicates encroachment.

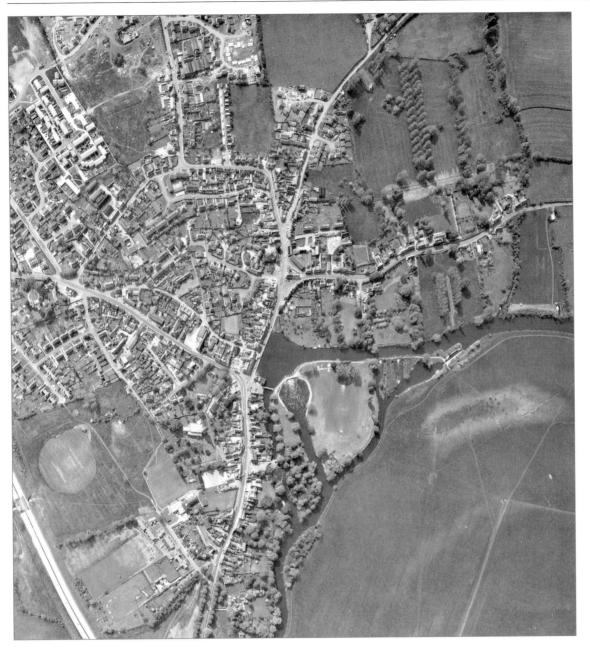

46 DANISH SETTLEMENT, GODMANCHESTER* (S)

The Danes conducted many raids in Cambridgeshire from the mid-ninth century AD, finally arriving 'with a vast army' in 870 and effectively cutting off the county and much of eastern England from the rest of Britain in the Danelaw. The importance of the Danish settlement at Godmanchester, close to the Danish *burh* (or planned defended town) at Huntingdon, is underlined by the first part of the town's name, which is derived from a Danish leader named Godmund.

It is likely that the Danes travelled from the coast up the rivers – in this case the River Ouse, which can be seen on the right, as it flows from Bedford (towards the right) to the sea (towards the bottom). The ruined walls of the Roman town were still standing in this period, and it appears that the Danes established a trading settlement just outside it, as happened elsewhere.

The pool, the large irregular area which lies up against the Roman town, was created as a safe anchorage for boats, together with its inlet and outlet channels. The road north of, and parallel to, the course of the inlet channel from the River Ouse may have formed the focus of the Danish settlement. The property boundaries of this small planned suburb still run down to the river.

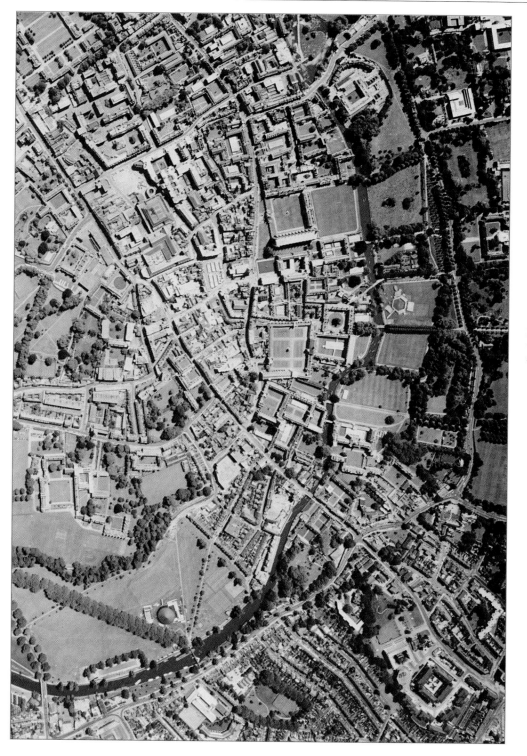

47 LATE SAXON CAMBRIDGE* (S)

The Roman and mid-Saxon town at Cambridge, deserted by AD 672, then later repopulated by King Offa of Mercia in the eighth century, was in the bottom right corner of the photograph on the north-west bank of the River Cam, which is curving its way round the west (right) and north (bottom) margins of this view. A small Danish settlement was established on the eastern bank of the river in the ninth century, trading as far afield as Ireland.

A new town was created at Cambridge on the eastern side of the river, opposite the Roman town and including the Danish quarter, by King Edward the Elder after he defeated the Danes in 917. The new settlement was bounded by the river on two sides, and a curving defensive ditch was cut between the upper and lower river to create an oval settlement. The ditch ran leftwards along the lane from the millpool (near top right) to the open space. Here it cut across the open space to connect with the short curving street near the left-hand edge of the photograph. From this point its line can be traced in short broken sections to the river.

The curving line of Trumpington Street, snaking its way parallel to the river from the top of the photograph, was laid out at the same time, together with the large market-place and several churches.

48 SAXON TOWN, SOHAM*
(SE)

This photograph looks over Soham. Soham Mere lay on the western (right) side of the town. Soham was first mentioned in AD 634 when St Felix is said to have founded one of the first monasteries in East Anglia here. The remains of a Saxon minster and early Christian burials have been found in the town, on the other side of the road to the present church.

Both churches stood on top of a small hill, which rises out of the fen and formed the focus for settlement. The diamond-shaped road pattern surrounding the hill and the church may be a relic of the late Saxon town which grew up around the minster.

The main roads connecting Soham with Ely (bottom left), the mere and Soham Lode (right) and the Suffolk uplands, including Bury St Edmunds (leading out of the top of the photograph) are all aligned on sharp changes in direction of the adjacent road. Was early Soham surrounded by a limiting bank and ditch, with gates planted at opposing corners? There are precedents in many parts of England for mid- to late Saxon town planning, particularly around the sites of important churches.

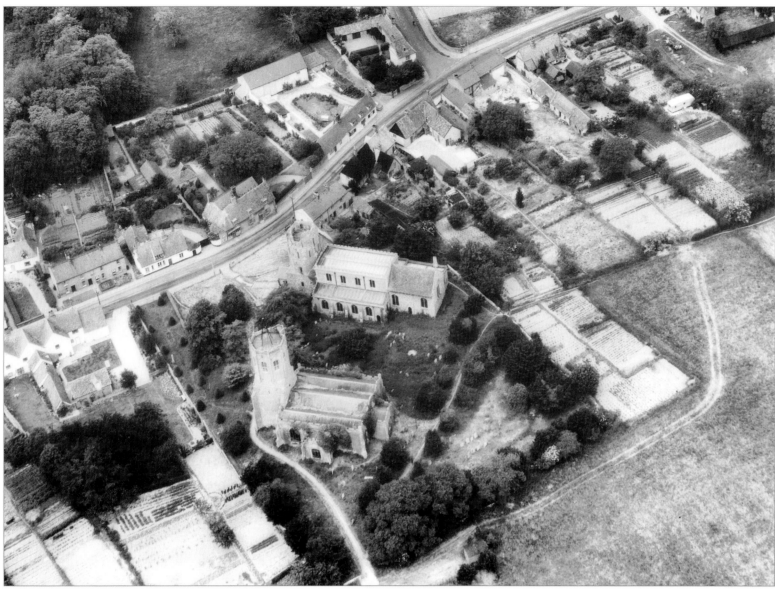

49 DUAL CHURCHES, SWAFFHAM PRIOR* (NNW)

At Swaffham Prior the churches of St Cyriac and St Julitta (left) and St Mary (right) intriguingly share the same churchyard. Unlike at Duxford, where two churches signified two settlements, the churches here are probably the result of a growing population in the eleventh century. There are many examples of two, or even three, churches sharing a single churchyard in East Anglia. Where documentary evidence exists (which it does not for Swaffham Prior), it suggests that by about the time of the Norman Conquest churches were unable to accommodate their growing congregations. To solve the problem, public-spirited religious freemen combined together to donate the money, and sometimes the land, needed to extend the churchyard, and to build another church to take the expanding church-going population. There were similar dual churches at Fulbourn and Histon.

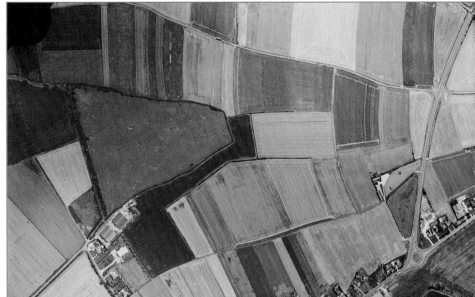

50 SOHAM NORTH FIELD* (E)

Lying off the Soham bypass (to the right of the photograph) are the remains of a medieval field system which has survived in a form amended by time. The gently curving road which leads north was the access way of the medieval farmers to their strips or 'selions', and the balk on which they turned their plough teams. Some of these strips have continued to be farmed as individual fields since they were first created in the early Middle Ages, and can be distinguished from the air by the different colours of the varying crops which each farmer plants on his strip. The strips have retained the backward 'C' curve of the medieval layout and are an intriguing puzzle of continuity and change.

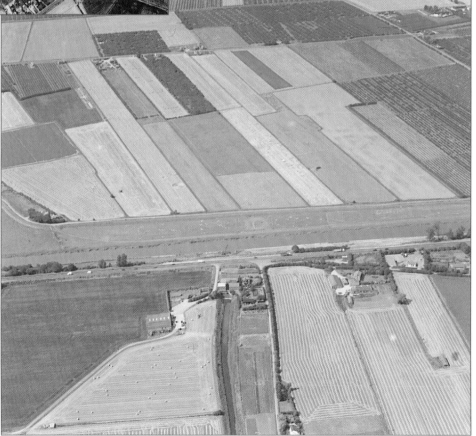

51 FEN FIELDS, WISBECH ST MARY (NW)

These long, narrow ditched fields are typical of the silt fens. Although the date of the fields shown here is unknown, they follow a tradition of fenland reclamation established in the late Saxon period. The lane enclosing this set of small fields follows a large drain which empties into the River Nene (running across the centre) – this ditch was almost certainly dug during the Middle Ages to enclose a tract of land which could be drained and subdivided into narrow fields. Each of the smaller subdivisions was itself enclosed with a drainage ditch which fed into the main drain and then into the river. In this way, communities were able to increase their arable land piecemeal as they needed to.

52 ROMAN BANK, LEVERINGTON* (W)

The so-called Roman Bank was built in the late Saxon period to protect the settlements of the silt fens against seawater flooding. It enters the photograph from the south-east (bottom) at an angle as a long straight bank with a lane on its seaward, easterly, side. At its junction with a number of small roads in Leverington, it curves right, carrying a road north towards Newton.

The bank was built on marshland, parallel with the ancient line of the Wash. The rain and river water which accumulated to the west behind it was released into the Wash at low tide through wooden culverts which went under the bank and were controlled by sluices. Initially the land behind the new defences was too salty to cultivate, but after a few years it was slowly brought into cultivation by enclosing small areas and then subdividing them with ditches into small fields. The drains west of the bank, which run on a north–south axis, were created in the Middle Ages to enclose small, rectangular ditched fields and remain a permanent record of the stages of reclamation.

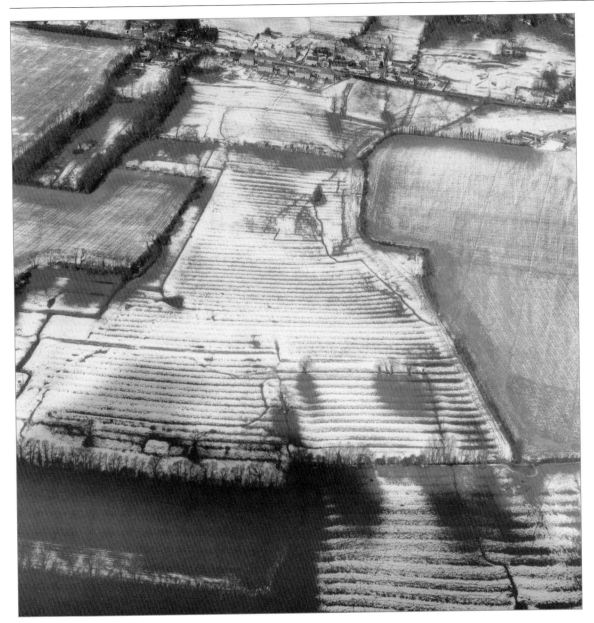

53 RIDGE AND FURROW, CROYDON (NW)

These long corrugations are the remnants of medieval fields and ploughing patterns. The ridges have fossilized strips of land, or 'selions', which divided the field between all the farmers in the village, including the manorial lord and the vicar. There were usually several very large fields – generally between two and five in south Cambridgeshire – which the village farmed in this way.

The distinctive curving medieval plough ridges can be seen in the south-east (near the bottom of the photograph) – the result of the ploughman thinking ahead, while he was still ploughing, about turning his oxen at the end of the ridge. The ridges were not an essential part of the medieval farming process: they tend to have been created by ploughing on heavy land, particularly the clays, and do not, in general, occur on the chalklands in south-west Cambridgeshire or on reclaimed peat fields where the land is very light.

To plough his selion, the farmer and his plough team would start at the bottom of the ridge and plough the first furrow up its centre. The plough threw the newly ploughed earth over towards the right, and made a furrow on the left. When he came back down the centre of the ridge on the second run, another ridge would be ploughed up against the first, with another furrow outside it. Round and round the ridge he would go, the plough throwing the land towards the centre and creating furrows on the outside, until – over the years – the central ridges built up and the final furrows deepened into this corduroy landscape.

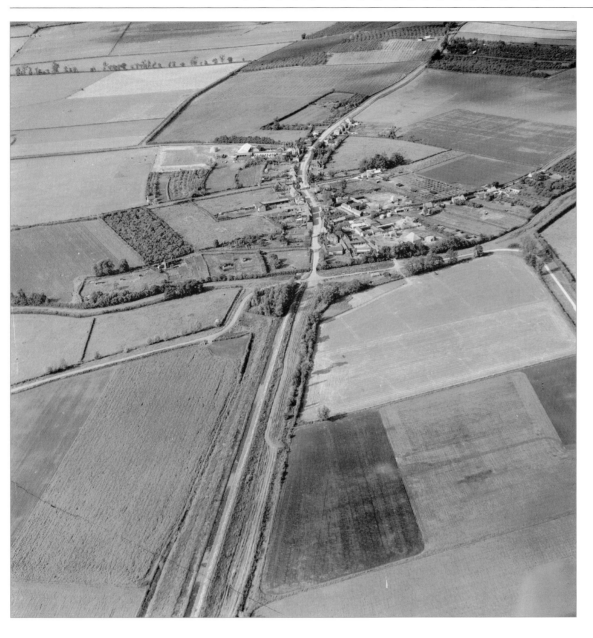

54 ALDRETH CAUSEWAY* (NNE)

The medieval road crossing from the Isle of Ely over the River Ouse into upland Cambridgeshire ran along the *Via Regia* (king's highway). This view shows the road approaching from the high ground of the isle in the north and dropping down the hill to meet the causeway (in the foreground) at the fen-edge at Aldreth. Although the route crossed the river and fen at the shortest point between the mainland and this promontory of the Isle of Ely, it still needed to travel across nearly 2 miles of waterlogged ground and river, particularly in winter, when the river was liable to flood. The medieval causeway was built to address this problem.

Aldreth Causeway is a substantial bank running straight across the fen from Willingham and still carries an unpaved lane. Although the first reference to the causeway dates from 1172–3, it is most likely to have been constructed by William I during his attack on Ely in 1080 or by Bishop Hervy of Ely, who built a similar causeway between Ely and Stuntney between 1109 and 1131. Maintenance of the causeway was the responsibility of many of the tenants on the bishop's manors, but was not always carried out. For example, for sixteen years around 1279 the bishop allowed the bridge and causeway to fall into disrepair, and travellers had to take a ferry where every horseman had to pay a halfpenny, and every pedestrian a farthing, generating large revenues. After the seventeenth century the route was superseded by the modern road, which travels further east between Landbeach and Stretham.

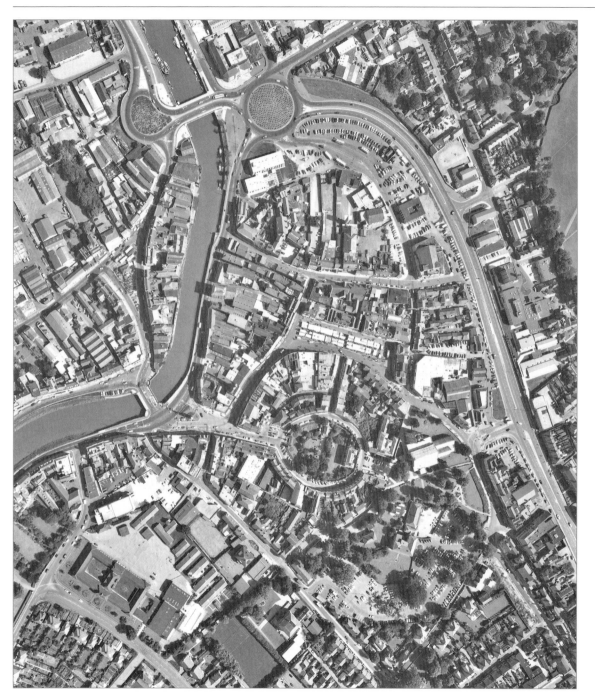

55 WISBECH CASTLE (NNE)

The motte-and-bailey castle at Wisbech was probably built within two generations of the Norman Conquest. It is traditionally attributed to William the Conqueror and his campaign against Hereward, but there is no documentary evidence to support this. There is a small possibility that the castle may have been built by the Bishop of Ely as it was owned by the bishops in the thirteenth century, but, as the large Ely manor was on the other side of the River Nene, this is unlikely.

The central motte of the castle no longer stands and has been replaced with a nineteenth-century building. This can be seen on the right of a small oval park at the centre of the photograph. The line of the bailey which surrounded it is preserved in the park boundary. It overlooks the River Nene and one of its crossings to the west.

The street pattern outside the castle appears to preserve a precinct, which includes the church of Saints Peter and Paul, and is possibly a planned Norman settlement. The market-place – now partly built over – lies just outside its northern boundary.

The curving dual carriageway on the right lies along the line of the Old Well Stream, one of the major fenland waterways, which was still flowing in the early Middle Ages.

4: THE NORMAN CONQUEST

AD 1066 – 1100

In the late summer and early autumn of 1066, Harold, the last Saxon King of England, marched twice through Cambridgeshire within the space of three weeks. First he travelled north to defeat King Harald Hadradra at Stamford Bridge; then he turned south to be defeated by William the Conqueror at the Battle of Hastings. On each occasion, Cambridgeshire men were raised to join his army. Many of them never returned to their estates, including Aluric, the Sheriff of Huntingdonshire, who owned an estate at Hemingford Grey.

Estates which had belonged to prominent Anglo-Saxon notables were confiscated and given to Normans who followed in William's train. For example, the vast Cambridgeshire estates of Eddeva the Fair were given to Count Alan of Brittany, William's son-in-law; while lower down the social scale, the small farms of freeholders (often no more than half an acre in size) were seized and amalgamated into larger manors by new Norman overlords, like Hardwin de Scalers.

Local resistance to the Normans was initially centred on the Danish armies which entered England through the rivers of the fenland system, but peace was made at Ely in June 1070, and the Danes left England. However, dispossessed Anglo-Saxon estate owners, like Hereward and Tostig, retreated with their followers into the impenetrable waterways and marshes of the Isle of Ely, a landscape perfectly suited to guerrilla warfare. William arrived in the spring of 1071 and laid siege to the town with his army.

A romanticized medieval record of the resulting skirmishes survives. Although it is probably factually unreliable about the events, it sheds a vivid light on the probable character of the fighting. In one attack the rebels

who were hidden all around in the swamp, on the right and left, among the reeds and rough briars of the swamp, set the reeds on fire, and by the help of the wind the smoke and flame spread up against their [i.e. the Norman] camp. Extending some two furlongs, the fire rushing hither and thither among them formed a horrible spectacle in the marsh, and the roar of the flames with the crackling twigs of the brushwood and willows made a terrible noise. Stupefied and excessively alarmed, they took to flight . . . Wherefore very many were suddenly swallowed up, and others drowned in the same waters, and overwhelmed with arrows . . .

The great causeway at Aldreth, across the River Ouse and its floodplain, is said to date from this period. The medieval main road which it carried, the *Via Regia*, was certainly the main road into the Isle of Ely for the next seven hundred years. William ensured the submission of the area with motte-and-bailey castles at Cambridge, Huntingdon and possibly Wisbech, while the new Norman earls of Oxford tried to impress their English tenants with a similar fortification at Castle Camps.

With England firmly in the Norman grip, the new manorial overlords set about reorganizing their estates. Some land was granted to Norman monastic houses, as at Swavesey and Isleham, as gifts in thanks for good fortune. On most Cambridgeshire estates – lay or religious – there was at least some reorganization as freemen were reduced to unfree peasants working the land they had formerly owned, and as new manors were created by amalgamating or subdividing earlier holdings. Only the monasteries tended to retain the land that they had held before the Norman Conquest, and even that was threatened. Osmund, the Norman lord at Hemingford Grey, seized more than a hundred acres in Hemingford Abbots from Sawin the Fowler, a tenant of the Abbot of Ramsey (at that time away in Denmark on business for the king), and minor Norman lords took various lands belonging to the Abbey of Ely at Melbourn and Meldreth.

56 CAMBRIDGE CASTLE* (ENE)

In 1068, William the Conqueror ordered a castle to be raised at Cambridge as part of his campaign against the Danes, and against Hereward and other English rebels who were still holding out in the Isle of Ely. Domesday Book records that twenty-seven houses were demolished to clear the site for the castle, and late Saxon finds have been made in its vicinity.

The tall, circular mound of the motte, once surrounded by a moat, stands on a hill overlooking the approaches of roads leading into Cambridge from the north, and the river. The line of the bailey has been blurred by later buildings and cannot be seen from the air – it lay north of the castle and included the formal block which houses Cambridgeshire County Council.

57 MOTTE-AND-BAILEY CASTLE, CASTLE CAMPS (NNW)

This castle was built by the earls of Oxford soon after the conquest, halfway between Cambridge and their seat at Hedingham. Although the castle buildings have disappeared, the circular defence defining the motte survives as a tree-lined ditch round the modern farm. The trapezoidal bailey runs north-west from the motte, its ditch also outlined by hedges and trees. The church stands in the line of the bailey ditch and may have formed part of the defences. The first bailey was a smaller one, and part of its line can be seen between the motte and the church tower. The disturbed field to the right of the approach road contains the remains of the deserted medieval village of Castle Camps, which grew up around the castle gate.

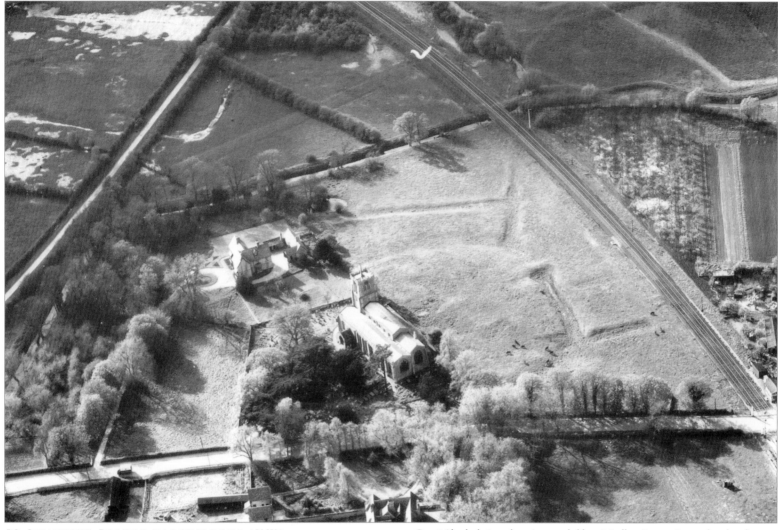

58 SWAVESEY PRIORY EARTHWORKS (NW)

The banks and ditches which lie around the parish church at Swavesey are the remains of a small Benedictine priory founded by William's son-in-law, Count Alan of Brittany, by 1086. (Spoil from nineteenth-century gravel working overlies some of the earthworks on the north side of the church.) The site lies on a small island rising out of the fen very close to the mainland on which Swavesey village stands. The deep ditch which runs almost parallel to the north of the church may have been part of a channel connecting the priory with the River Ouse, which ran along the north of the parish.

Count Alan had given the priory, probably originally a Saxon minster church, whose small community of priests had served the surrounding parishes, to the Priory of Saints Sergius and Bacchus in Anger in France. It was always a small house with just a few monks. The monastic church was the nave of the present parish church, and the current south aisle was the parish church. In the late fourteenth century the king gave the priory to his new Carthusian house at Coventry, and the monks left Swavesey. Thereafter the site was run as just one of many manors from Coventry, and the buildings gradually fell down.

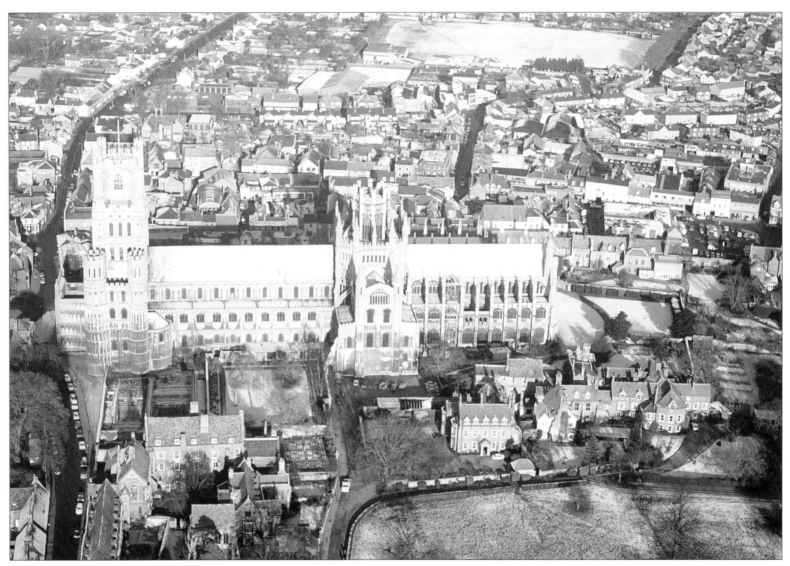

59 THE ABBEY, ELY* (N)

This Benedictine abbey was founded in 673 by Etheldreda, an East Anglian princess and Queen of Northumbria, on land which was probably given to her by her father on her marriage. The abbey flourished but was badly affected by Danish attacks in 870 and – like many Cambridgeshire monastic houses – was refounded in 970 in the great late Saxon Benedictine revival and embellished by the Norman abbots after the conquest.

The beautiful Norman abbey church dominates this view. To the right of the church, a cluster of houses was built along the nave of the monastic infirmary where the sick and aged monks were treated. By a curious mischance, the nave of the infirmary has fallen down to become Infirmary Lane. At the east of the lane, Diocesan offices occupy the site of the infirmary chapel; on the south, the larger house is that of

visiting Benedictine monks, the Black Hostelry (named after the colour of their robes); and to the west the smaller house is that of the monastic cellarer (who had charge of making or buying the beer and wine which the monks consumed). On the north of the lane the easternmost house was built in the fourteenth century as a place where monks could meet their families privately, and the next house may have been used as the infirmary mortuary. The monks' cemetery lay between the infirmary and the church.

Another cluster of buildings lies west of those around Infirmary Lane. Now occupied by the bishop and the King's School, they were originally built for the abbot (who had control of the monastery and all its lands) and the prior (who managed the daily running of the abbey).

5: THE HIGH MIDDLE AGES

The 250 years following the Norman Conquest saw rapid economic growth in England. The weather was warm enough to grow vines in many places, including Peterborough and Ely. The population grew from between 1½ and 2 million people in 1086 to perhaps as many as 4 million in 1300. The population of many villages increased dramatically, and this can still sometimes be seen in the landscape. At North Street, Burwell, for example, people settled on strips in the fields near the fen-edge, once the original village near the church had become too overcrowded.

As a result, wages remained low – the economy depended primarily on agriculture, and people jostled for places on the manors. The pace of clearing uncultivated land and fenland drainage accelerated. The price of wheat and other grain remained generally high, and there were large profits to be made from farming as the population grew.

Communication by water was cheap and efficient compared with road transport, and the warmer weather meant that these routes were open for most of the year. The ditches and canals dug for flood prevention necessarily linked up with the main fenland rivers, and they were also used for local and international shipments of goods and agricultural products. For example, at Isleham, three public docks were linked with each other, with private wharves and the River Lark – a major fenland river which linked the area with King's Lynn – while in 1199 ships from Swavesey were travelling in the North Sea when they were attacked by pirates.

Manorial lords bought the right to hold markets and fairs on their rural manors, in the (often realized) hope that this investment would pay off in the development of a thriving commercial centre, the rents and taxes of which would line their pockets. At Linton, for example, less than an acre of agricultural land was sacrificed for a market, and this brought the manorial lord an increase in income of 50 per cent. At Swavesey, first the prior and then the lord of the manor invested in the creation of docks and markets, and a small town developed as a result. At Kingston a new market was laid out next to the old village. The medieval fairs at Stourbridge in Cambridge and at St Ives took

60 Peterborough Abbey (W) showing the green, Abbot's lodgings, cloisters and infirmary.*

their place among the most important fairs in Europe, lasting for several weeks at a time, importing goods from as far afield as Sweden and Spain along the fenland waterways.

The monasteries often owned huge tracts of land – the abbey at Ely owned all of the Isle of Ely from Stretham to Wisbech, as well as a large chunk of west Suffolk and various manors in south Cambridgeshire – and made notoriously large profits, the results of which can be seen in the stunning buildings which survive to this day. Markets were held outside the monastery gates at Ely, St Ives and Peterborough, while towns were also developed by the houses at Ramsey and Chatteris.

There was some political unrest in the twelfth century, and castles were built at Burwell, Rampton and (possibly) Swavesey. However, the threat was shortlived and the earthworks remained unfinished. Their lasting legacy was the influence that they had on owners of manors – everyone wanted a moat as a symbol of wealth and prestige which shadowed that of the king. Many manors were moated in the two centuries between 1150 and 1350, some with very elaborate waterworks, as at Bassingbourn. Gardens were also created for the same reason, and it has been said that their remains are among the most common surviving medieval earthworks. Some were small and private, like that at Caxton Moats, but others were intended for display, like that at Somersham. In many cases – as, for example, at Shingay – the moat was an integral part of the garden design, and while fish may have been kept in the moat, moats were not built for fishponds (or for defence).

The university in Cambridge, whose students were first mentioned in 1209, continued the medieval tradition of providing teaching by qualified masters for students who came to the schools which were held in churches or hired buildings. The students lodged in the town. In the early to mid-thirteenth century, different monastic orders bought or built lodgings for their students in Cambridge. From 1284 onwards, starting with Peterhouse, colleges for students – independent of the different orders and of the Church – were founded by various benefactors, and by 1318 the Pope confirmed that Cambridge was a *studium generale* – a university. These developments inevitably affected the growth of the town for the foreseeable future, as the wealth and influence of the university increased.

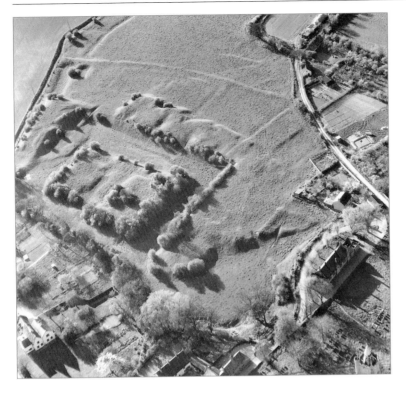

61 BURWELL CASTLE* (NW)

These impressive fen-edge earthworks at Burwell date from *c.* 1143, when Earl Geoffrey de Mandeville rebelled against the king and seized the Isle of Ely. King Stephen responded by fortifying the fen-edge at Burwell (and Rampton). The irregular spoil mounds outside the moat partially cover the ditched boundaries of properties, the inhabitants of which may have been removed to make way for the castle. The substantial moat was filled from springs (near the bottom right) where it widens out into a large triangle. The rectangular platform inside the moat was constructed with raised areas on either side and a central depression. In August 1144, Earl Geoffrey and his retainers attacked the (still incomplete) castle. He was mortally wounded in the skirmish which followed, and there was no reason to continue with the building. The spoil mounds outside the moat and the low terraces inside show that the work was incomplete when it was abandoned.

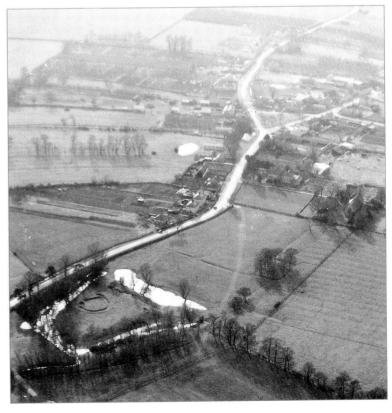

62 CASTLE AND VILLAGE EARTHWORKS, RAMPTON* (SW)

The impressive water-filled moat of a castle of the same period at Rampton lies in the south-east (left) of this view. The castle protected both the fen-edge and the fen-edge road, which can be seen running past it on the south. Village earthworks lie along a hollow-way between the north-west corner of the castle and the church. The village may have been moved to make way for the castle, and a planned settlement was laid out around a large triangular green (near the top). The semicircular ditches on the castle mound were made by fortifications during the Second World War.

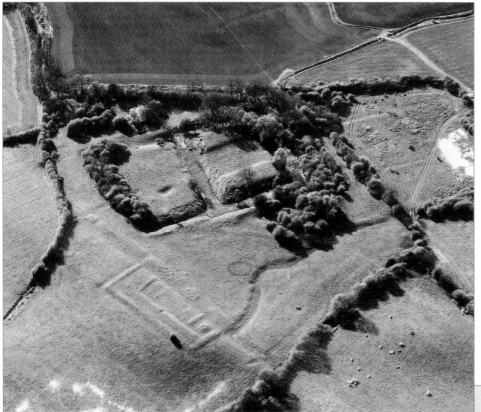

63 CAXTON MOATS (W)

This double-moated site lies deserted along what was once a major road between Eltisley and Caxton. The platform inside the northern moat of the pair was built up in an exact replica of Burwell Castle and was probably constructed by the de Scalers family in the twelfth century as one of their seats. There is some debate about the motive for these earthworks: was a castle intended? Most medieval moats date to the period from about 1150 to 1350, and they were primarily intended to impress. What could be more impressive than a moat which echoed the king's own nearby works? The rectangular banks and ditches to the south-east of the main site are fed by a winding stream which runs out from the moat, and they may be the remains of a medieval garden. The site was deserted by 1500.

64 CROYDON MOATS (WSW)

These two moats at Croydon lie within an enclosure which includes both sides of a once-substantial road. The original house probably stood inside the moat nearer to us, with its outlying building protected from the ridges of the surrounding medieval cultivation by the hedge-lined ditch which encloses the site. The second moat, further from us, was built later and may have been constructed as a moated garden. Both were almost certainly constructed by the owner of one of the manors in Croydon who wished to impress his neighbours, friends and relations.

65 ANGLESEY ABBEY, LODE* (N)

The large house (centre) is built on the thirteenth-century remains of an Augustinian priory, founded *c.* AD 1212 and converted to a domestic dwelling in the early seventeenth century. Some stone and the roof is said to have been taken to Madingley to build Sir John Hynde's new hall (85) there in 1541. Behind the house, running at a slight angle from right to left, is the hedge-lined lode along which barges brought good grey stone from Barnack, near Peterborough, for the building of the priory. The lode continued in use for long- and short-distance water-borne trade until the seventeenth century, when the mill cut the harbour at Lode off from the canal.

In the foreground is a fine rectangular moat, whose feeder streams can be seen at its northern corner, linking the moat with the lode. The moat contains a raised platform and is surrounded by a broad, flat bank. The channel for the feeder stream can be seen around the outside of the bank, leading into a small triangular lake on the southern corner. Two rectangular fishponds lie in the northern corner of the moated platform.

As the priory buildings stood a little to the north of the moat and its channels, it is possible that these earthworks are garden remains associated with the priory.

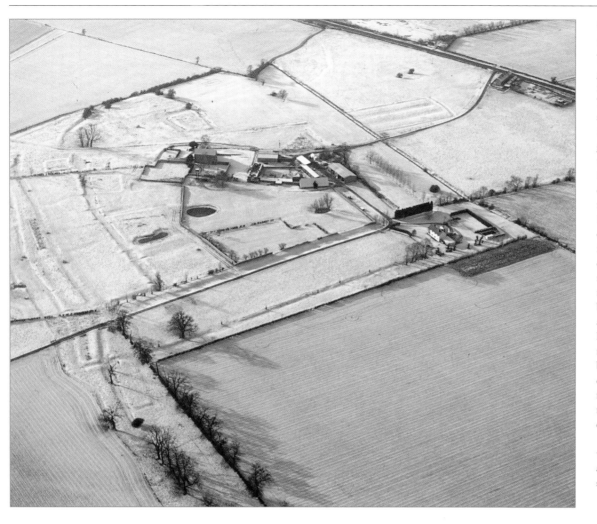

66 DENNY ABBEY NEAR WATERBEACH* (W)

This seventeenth-century farmhouse in the grounds of a modern farm and its buildings is almost all that remains of Denny Abbey. This small gravel island rising above the surrounding flooded fenland was given in 1159 to the abbey at Ely. Eventually it was granted to Marie de St Pol, the young, wealthy and widowed Countess of Pembroke, who used it to refound a house of Franciscan nuns (the Poor Clares) in the mid-fourteenth century. She remodelled the Benedictine and Templar buildings into her domestic quarters – now preserved in the farmhouse – and to the east she built a new church, which has now disappeared, for her nuns, directly in front of that building. The nuns' dormitory lay to the north of the building, along the line of the garden wall, and behind it to the west were small offices, kitchens and gardens around a well. The nuns' refectory survives as the large stone barn set almost at right angles to the camera, a little distance to the north of the farmhouse. After the dissolution of the monasteries in 1538, the house was converted to a farmhouse.

The complex ditches and platforms which surround the house are probably almost all remains of a Romano-British settlement.

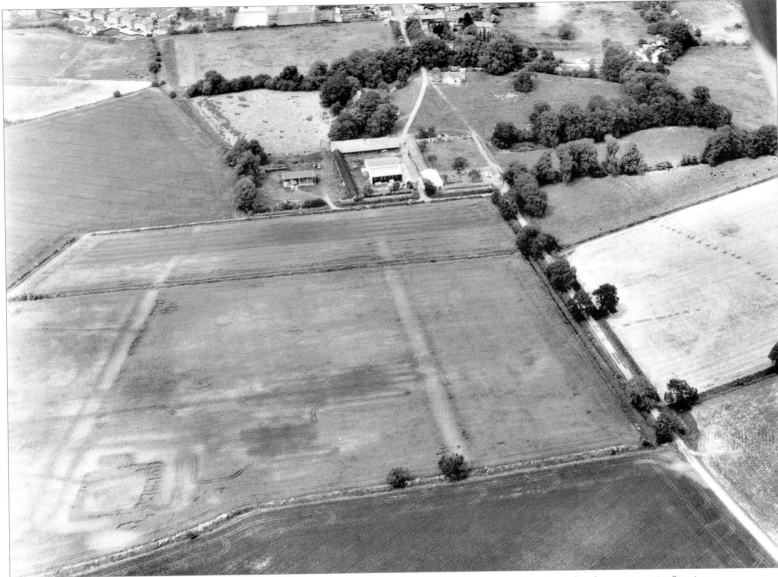

67 BISHOP OF ELY'S PALACE GARDENS, SOMERSHAM (N)

After 1109 the Bishop of Ely began to create elaborate gardens around his palace at Somersham, which stood on the site of the farm buildings in the middle distance. The gardens lie symmetrically placed on either side of the raised causeway, known as Lady's Walk (which travels from top centre to bottom right), which allowed views across the various parts of the garden. Immediately above the farm buildings is a very large oval moated area where the slight earthworks of small enclosed gardens remain. Above the moat the large rectangular area (on the left of the approaching street, mirrored by a similar rectangle on the right, now built over) was created as a huge water-filled pond, supporting duck, swan and heron. These artificial

lakes flanked the entrance to the palace and made a most imposing first view.

To the right of the farm buildings lie ornamental fishponds and a terraced walk with gardens below the terrace. Below these, on either side of Lady's Walk, were symmetrically placed gardens of which little now remains. The parallel bank just to the left of Lady's Walk was probably also a raised walk, and it seems that an ornamental orchard lay between the two. To the left of this again, a ditch and a small moat can just be seen at the bottom left – possibly the ruins of a small water garden. To the right of Lady's Walk, nothing now remains. The boundary of the garden followed the track which runs east–west (across the bottom of the photograph).

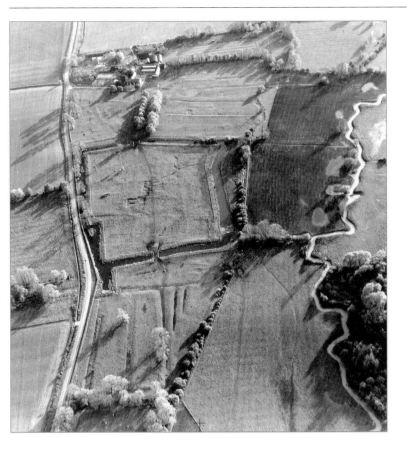

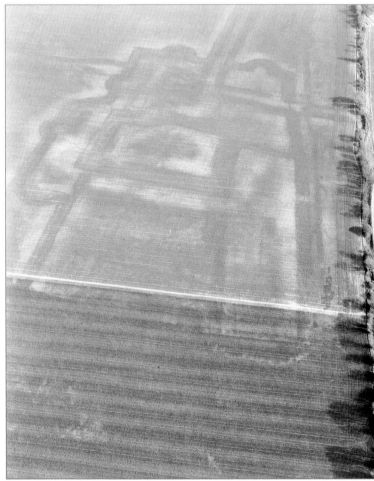

68 PRECEPTORY OF THE KNIGHTS HOSPITALLERS, SHINGAY (WSW)

This large and imposing moat once contained the fourth most important house of the Knights Hospitallers in England. The remains of an orchard with a few aged fruit trees stand in the top left corner of the moat. The moat was fed by a stream of the Ashwell Cam, which runs past the site on the right. The widening of the moat at its bottom left-hand side probably represents the ruins of a small lake across which the visitor from Cambridge first saw the house. The buildings were converted to an imposing country house after the dissolution of the monasteries, and their foundations can be seen in the centre of the site. An elaborate system of rectangular waterfilled ditches, the purpose of which is not properly understood, lies below the site.

69 'JOHN O' GAUNT'S CASTLE', BASSINGBOURN (SW)

Built by Warin of Bassingbourn in the late twelfth century, only soil and crop marks remain of this ornate house and garden. The entrance from Bassingbourn ran from the top centre of the photograph along a raised causeway. The dark lines (centre) are those of ditches around the walls of the house and garden. The causeway passed between elaborate walled gardens into a large rectangular court. The house, which lay in an imposing ornamental moat, faced on to the court. Behind and on either side of the house were elaborate gardens divided into large compartments by moats or ditches.

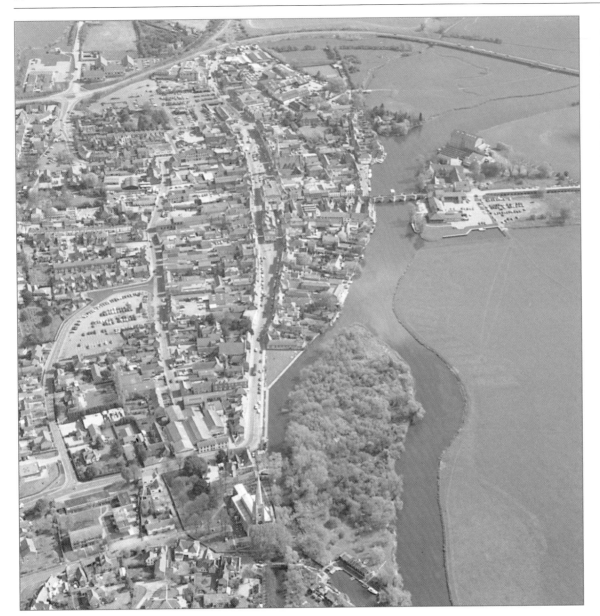

70 ST IVES* (ESE)

The original village at St Ives was at Slepe, a small settlement around the parish church (bottom), near a ford over the River Ouse. It was given to Ramsey Abbey in 970 as part of its endowment.

In *c.* AD 1000, a farm labourer found a stone coffin which contained a burial with grave goods, including a chalice. With hindsight, it was almost certainly Romano-British, but was opportunely interpreted as the tomb of St Ivo, a Persian saint.

At once, Ramsey built a priory dedicated to St Ivo (near the top of the photograph), a little distance from the church at Slepe. From 1110, a market and a fair were held in the open space between the priory and the village. The latter developed into one of the four great fairs of England, lasting for three weeks and bringing the abbey at Ramsey a considerable income. Over time, the market has been encroached upon and filled in as the abbey granted its tenants permission to build along the main street between the church and the monastery.

By 1107 a bridge had been built downstream of the original ford, so that travellers between the north and south banks would have to pass through the monastic town, and by 1200 the settlement had become known as St Ives.

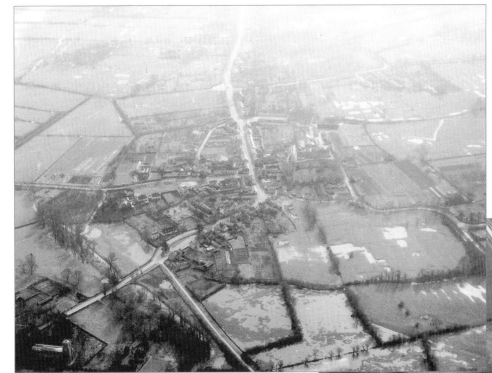

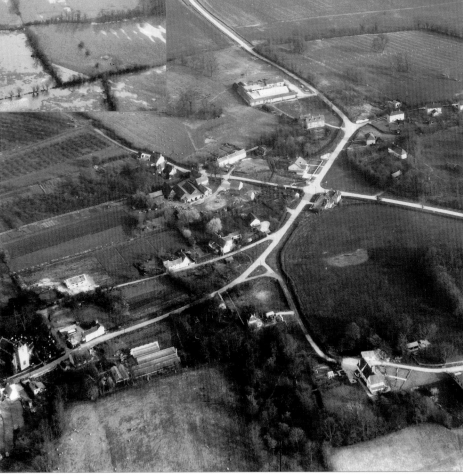

71 PLANNED TOWN, SWAVESEY* (SSE)

Swavesey lies on a small promontory jutting out into the fen and was protected against flooding by the hedge-lined ditch which can be seen encircling the modern town, and which also connected Swavesey with the fenland waterways. In the early thirteenth century the priory created a hythe with properties for merchants on either side; its ruins can be seen where the road running into the town (from bottom left) widens into an oval space. Within twenty years the lord of the manor had built another hythe, also flanked by planned properties just above it (along the road coming in from centre left), to complement his market grant. It has also been filled in, although it remains as open ground and still contains a little water in a pond.

72 PLANNED MARKET, KINGSTON* (SE)

The early medieval settlement at Kingston lay just to the right of the church around a small rectangular green, defined by lanes and now mostly built on (bottom left). After the lord of the manor obtained a grant for a market in the early fourteenth century he built a new green for his market to the right of the old village. It lay in a diamond around the junction of four roads (top right) and can be seen outlined by hedges. Sometimes the hedges lie along the back boundaries of houses which encroach on the green, sometimes along the front where buildings have respected it.

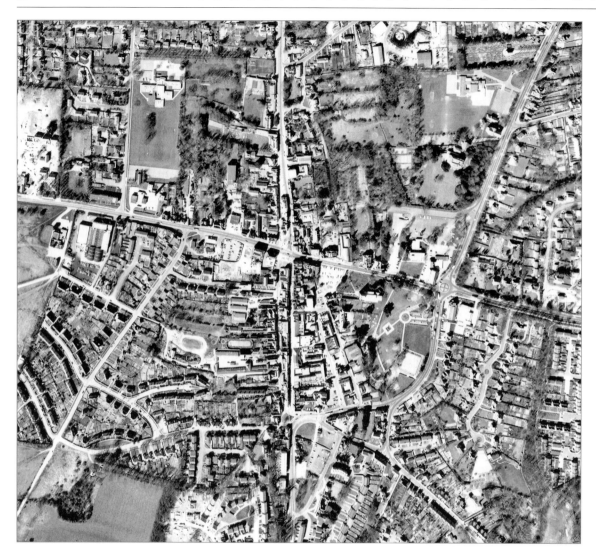

73 NEW TOWN, ROYSTON* (N)

In the late twelfth century a small priory dedicated to St John the Baptist was established on heathland at the intersection of Ermine Street and the Icknield Way. Close by, a wayside cross had been set up by a Lady Roisia and a hermitage may also have stood nearby. Ermine Street runs in a characteristic Roman straight line through the town (from top to bottom). The priory stood in the area of the church, to the right of Ermine Street. It suffered badly after the dissolution and much of the site now lies under the public gardens. The monastic precinct was probably outlined by the road, which curves around the right-hand edge of the gardens.

In 1189 the priory paid for a grant to hold a Wednesday market and a fair at Pentecost, and a large market-place was laid out to the west of the monastic buildings. The irregular open spaces and boundaries of encroaching properties in the area between the priory and Ermine Street indicate the probable extent of this early market.

The market prospered and a new town grew up, named after the wayside cross. A suburb for traders may have been laid out on the far side of the market from the priory, where the regular properties stretching away from the street suggest an element of planning.

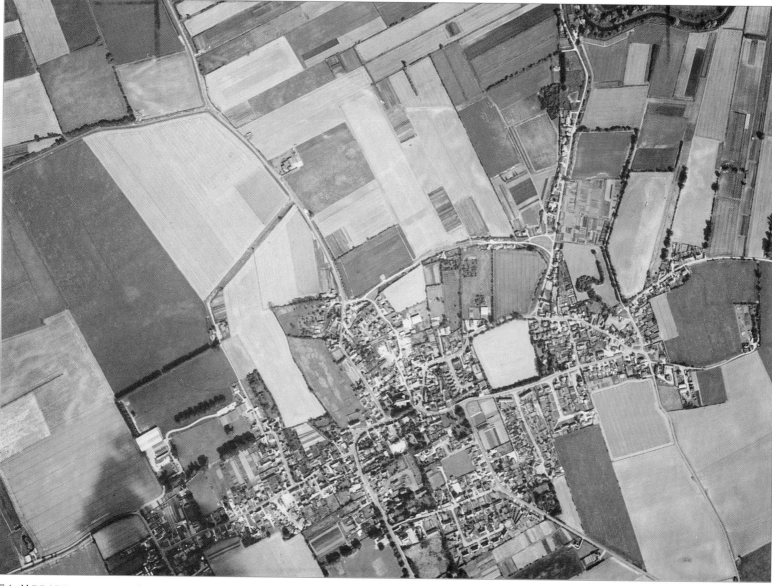

74 MEDIEVAL PORT, ISLEHAM* (N)

A trackway, lined on the left by a row of houses, enters the village from top right. Now called Waterside, it lay along a water-filled channel which linked the village with the River Lark, a major fenland river.

It leads to a large triangular green (where the present lane first intersects with another) on the site of a major hythe, where boats could land and take on goods. The second lane was once the bank on the north side of a further linking canal which lay on the flood line, protecting the settlement against flooding and also acting as a route for boats. Another smaller triangular quay lay at the western end of this canal and lane. This is now entirely built over, although its outline has been preserved by roads and a footpath.

The canal continued to the west, although its line is not visible on this photograph. The properties which backed on to it had their own private cuts, which allowed the owners to bring their goods right to their own back doors.

One of these cuts can still be seen on the ground and from the air. A road enters from the bottom centre, then curves right in the centre of the village. Immediately above the turn is a building with a long pasture field behind it. Running up the centre of the field is a silted-up canal. As the building is the remains of a monastic house in the care of English Heritage and the field contains a public footpath, both may be examined from the ground.

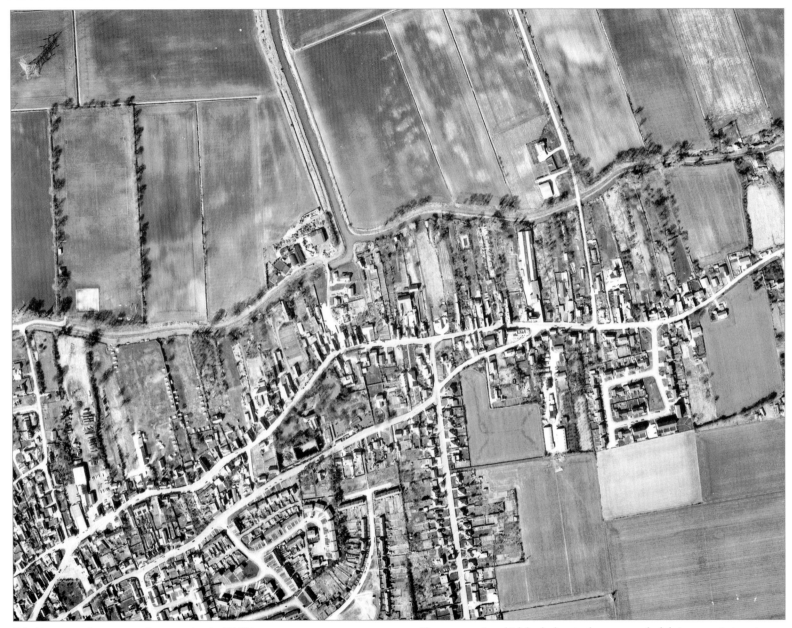

75 NORTH STREET, BURWELL* (NW)

The rapid population growth of the early Middle Ages is reflected at North Street, Burwell, by the development of properties in the fields as occupation spilled out from the earlier village around the church. The new part of the village lay some distance away along a road which ran parallel to the fen-edge ditch or canal. The road was originally a headland where farmers ploughing their ridges turned their oxen, and houses and their gardens were laid out on the cultivation strips on either side of the headland. This was unplanned ribbon development where people built their houses and enclosed their gardens from the fields as the need arose.

Those properties which backed on to the waterway had their own private cuts which allowed punts and other small craft to bring goods right up to the back door, and gave access to the major fenland waterways along Burwell Lode, which can be seen travelling out of the top of this view across the peat fens. The junction of the lode and the fen-edge canal was probably one of the attractions of this part of the fields, and large public hythes developed – one of which can be seen at the junction. These canals continued to be used for access and trade until the mid-nineteenth century.

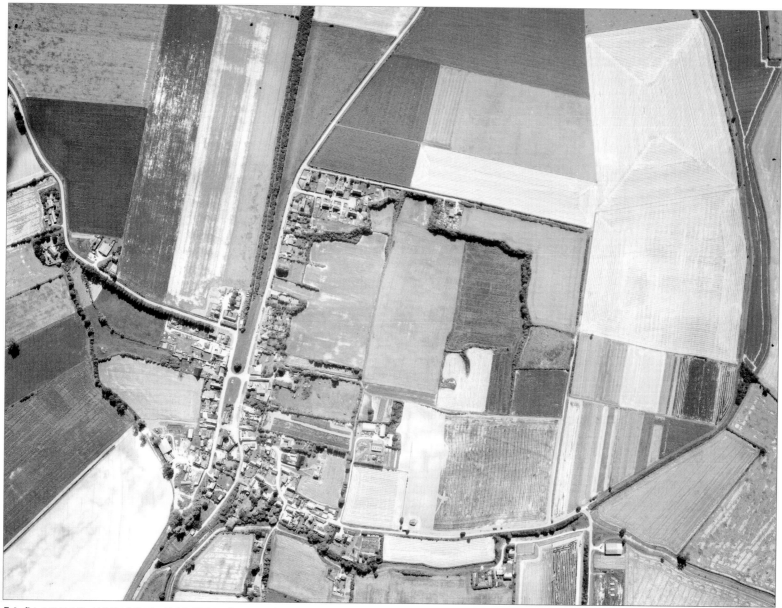

76 PLANNED MEDIEVAL MARKET, REACH* (NW)

The long, straight double-hedged feature which enters at the top of the photograph is the Devil's Dyke (32), which is aligned across the Icknield Way on Reach Lode (27). The settlement lies on a promontory reaching out into the fen, and the fen-edge is marked by an irregular semicircular ditch, which travels all the way round the lower part of the picture from west to north.

Settlements grew up on either side of the dyke during the early Middle Ages, to take advantage of the trade which travelled down Reach Lode, and developed into East and West Reach.

By 1201 the two villages had a joint fair, the rights over which Henry I granted to the townsmen of Cambridge. To encourage the fair, the villagers demolished the end of the Devil's Dyke to create a large rectangular green. A hythe or landing-stage (now partly lost to encroachment) developed on either side of a broad tongue of land which reached out alongside Reach Lode. A subsidiary cut was dug along this small peninsula's west side to create more anchorages for traders. Grain, timber and iron passed through the port, as well as 'clunch', Cambridgeshire's soft local limestone. The irregular hedgeline of the huge clunch pit lies immediately to the right of the dyke.

The fair flourished until the opening of the railway in 1884. Although it has much declined in size since its heyday, it is still held and still opened with much pomp by the Mayor of Cambridge.

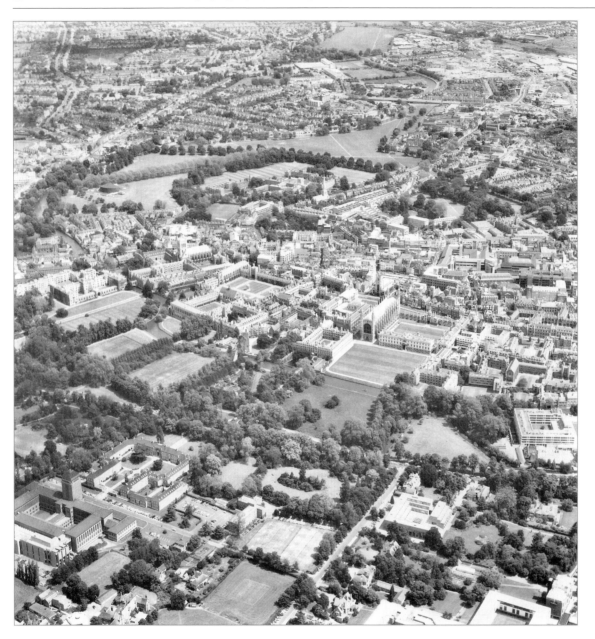

77 COLLEGES OF THE UNIVERSITY OF CAMBRIDGE* (NE)

The colleges lie along the river, from St John's College in the north to the distinctive quadrangles of King's College in the south, each embodying the medieval idea of a community of monastic students.

The plan of these medieval colleges was fossilized in the conventional form of contemporary aristocratic establishments. The main buildings of the colleges were ranged around a large courtyard, screened from the outside world by a formal gateway within an eastern range of rooms, which often included the master's lodging. On the north of the court lay the college chapel; and on the west, opposite the gateway, stood the hall, in a range which included kitchens and storage rooms, from which it was separated by a narrow screens passage. The college library often lay in the same range as the chapel, and the students' and fellows' lodgings lay opposite in the southern range of the court.

Colleges were endowed by religious or secular benefactors as lodgings for students who would not otherwise have been able to attend the university. They often included rebuilt or enlarged houses near the river, on sites augmented by additional parcels of land. In the process the houses of well-to-do merchants disappeared along with lanes (like Milne Street, which survives in short stretches parallel to the river, for example, just to the north of King's College Chapel) and churches (like St John Zachary, which lay immediately to the west of King's College Chapel).

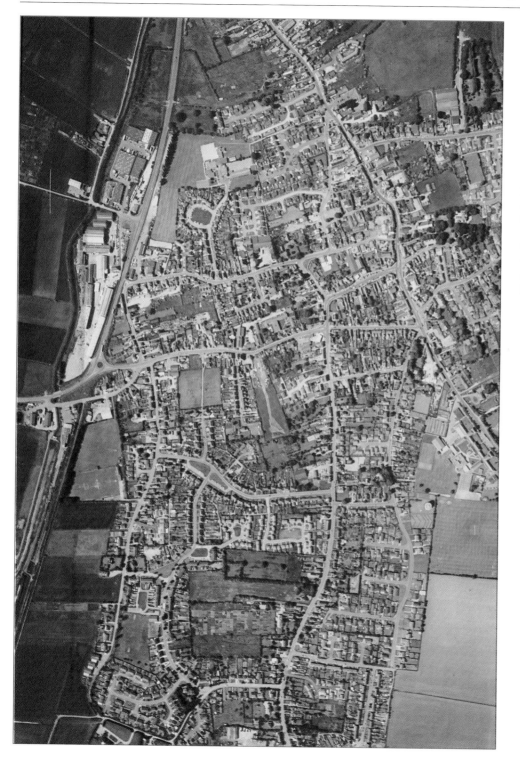

78 CHATTERIS* (N)

Between 1006 and 1008, a small Benedictine nunnery dedicated to St Mary was founded at Chatteris by the Abbot of Ramsey on behalf of his sister Aelfwen. It was always small, disappeared entirely during the dissolution in 1538, and is now preserved only in the street pattern. The main street of Chatteris, lying along the spine of the long fenland island, travels from centre top to bottom right. Another road leads in from the centre bottom and curves right to meet the first. The nunnery lay enclosed in the angle below these two roads, which formed the northern, western and part of the eastern boundaries of its precincts. Its site is now bisected by a new road, which cuts across from left to right. Below this new road another west–east road defines the southern edge of the nuns' precinct.

The town grew up outside the northern gate of the nunnery with a planned settlement facing on to the nunnery's northern wall. As the town expanded, properties were built in a ribbon development on the open field strips on either side of the headland, which now forms the town's main street.

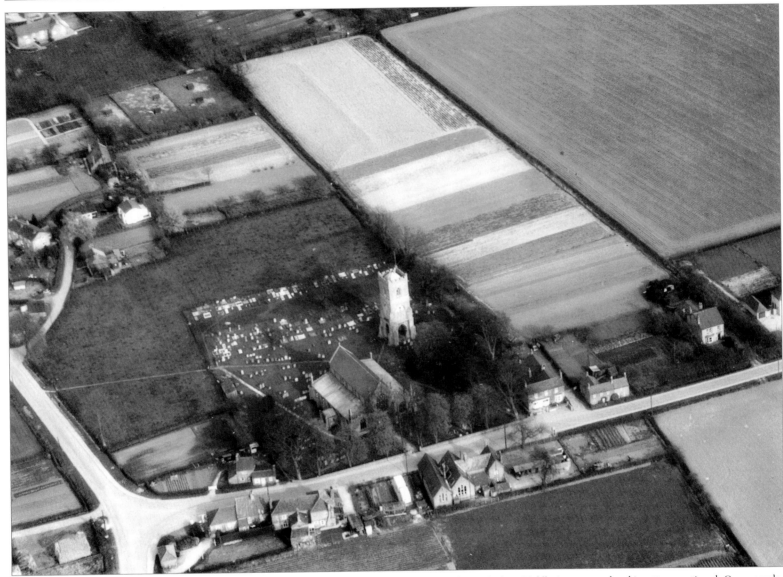

79 PARISH CHURCH, TYDD ST GILES* (SE)

Tydd St Giles is the most northerly Cambridgeshire village, lying near the Wash and on the Lincolnshire border. The detached thirteenth-century church tower, with its ground-floor arches, is typical of many silt fen churches, where it was hoped that separating the church and tower would present a lesser obstacle to floodwaters. Melting snow and heavy rain from the uplands or unfortunate combinations of high tides and high winds led to frequent flooding. The church here was certainly in place by the twelfth century, as its Norman nave shows, but its chancel was swept away by floods, and the chancel arch was built in.

Parts of the silt fens were flooded nearly twelve times between 1250 and 1350. Even poorer weather in the later Middle Ages meant that this pattern continued. One example among many records shows that in 1467, for instance,

there was scarcely a house or building, but what the stream of water made their way and flowed through it. Nor must you suppose that this happened hurriedly and in a cursory manner only: but continuously, during a whole month, the waters either stood there without flowing off, or else, being agitated by strong gusts of wind, swelled and increased still more and more day after day.

(Darby, 1983, p. 56)

6: THE LATER MIDDLE AGES

AD 1300 – 1500

The tide of economic prosperity which had characterized the early Middle Ages began to ebb towards the end of the thirteenth century. The weather, which had so favoured wheat production before 1300, became more changeable. A series of wet summers caused the crops to fail or to rot in the fields, while warm winters resulted in years of sheep and cattle murrains. By the 1320s, much agricultural land in Cambridgeshire, particularly on the clay plateaux, was abandoned as it became too difficult to work. In many places, dearth and starvation were familiar visitors between about 1290 and 1350. Fenland flooding from the sea (the result of a bad combination of tide and wind) and from the uplands (as the rivers and drains were unable to cope with the quantities of rainwater) worsened in the fourteenth century. It is said that the common separation of church buildings from their towers seen in the silt fens was an attempt to reduce flood damage – there is a lovely example at Tydd St Giles, where the thirteenth-century tower is set 60 feet away from the church, the chancel of which was washed away in flooding.

In the spring of 1348, bubonic plague – the Black Death – arrived in southern England and was gradually spread by travellers and traders, reaching Cambridgeshire in March 1349, where many people were already weakened by years of malnutrition. At Thorney, 13 monks and 100 monastic servants died, and at Dry Drayton, 20 out of 42 tenants on the Crowland manors succumbed. People died in unusually large numbers throughout 1349, and the death rate only began to fall towards the more usual levels in 1350.

The long-term effects on the landscape of this half-century of adversity can still be seen. It is estimated that 39 per cent of the population died as a result of the Black Death. Although no villages were deserted as an immediate result, houses and lands were left vacant on those manors where the soil was heavy or the landlord strict, as tenants left for easier places elsewhere, left empty by victims of starvation or plague. Occasionally the platforms of their houses (as at Great Eversden and Toft) or the ridges of acres left untilled (as at Wimpole and Longstowe) can still be seen.

Wheat prices, which had been very high, fell dramatically. The reduced population meant that demand had fallen; on the other hand, wool prices continued to rise, peaking between 1450 and 1550. Many peasant farmers turned to sheep alongside their arable farming, enclosing strips in the fields and renting manorial land for their flocks. Those who were successful gradually emerged as the new yeoman classes of the later fifteenth century whose houses still stand in many villages. In these parishes, small-scale enclosure was common. In other places the landowners took the initiative, gradually buying up all of the freehold land in the parish and eventually ejecting the remaining labourers to enclose large tracts of land for sheep. At Clopton, for example, the village was enclosed in the early sixteenth century, while at Landwade the process seems to have occurred about a generation earlier.

Not all change should be attributed to the economic depression or the Black Death. In many places there was positive growth and recovery. At Knapwell, for example, changes in patterns of trade caused the main village street to shift its axis from west–east to north–south. Churches were embellished with towers, aisles and clerestories, and surviving late medieval houses are of high quality.

The university at Cambridge continued to grow, with increasing numbers of colleges being founded during the later Middle Ages and the building of the old schools as teaching rooms for the university students. By about 1400 the college plan had evolved: ranges of buildings including a gateway, a chapel, a hall and buttery, a kitchen, and rooms for the students were set around one or two courtyards, reflecting and fossilizing the practice of high-status manor houses of the same period.

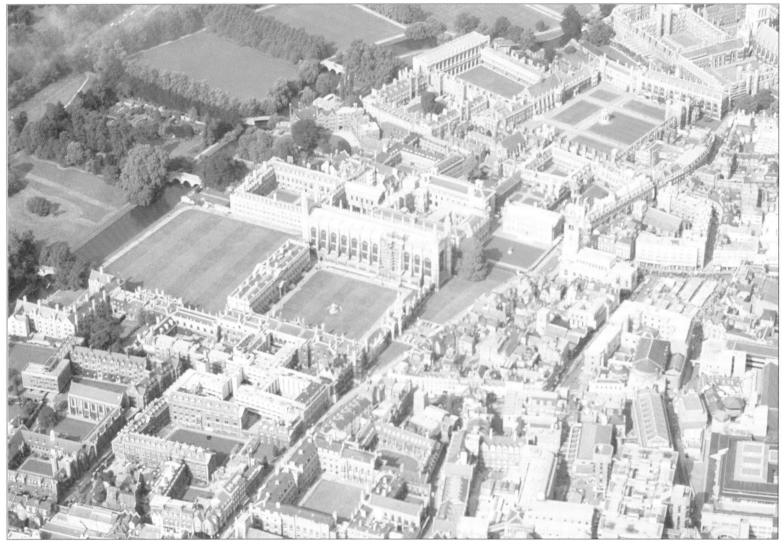

80 KING'S COLLEGE, CAMBRIDGE* (NW)

King's College, like many in Cambridge, is a good example of a medieval foundation which has developed and grown at different stages since its inception. The King's College of St Nicholas was originally founded by Henry VI in the wintry months of January 1440–1, for a rector and twelve scholars. Building began at once on the site between the river and King's Parade, and the premises were further extended by the acquisition of more land, closing several lanes and St Zachary's church in the process. The college chapel was begun in 1446, and the first stone was laid at the high altar by King Henry on 25 July. The college was not completely finished until about 1538. Two generations of masons, carpenters, plumbers, glaziers and many other craftsmen laboured over this building, and it remains one of the glories of late medieval religious architecture in Europe.

Changes in royal patronage and lack of money inhibited further major building at the college until the eighteenth century, when James Gibbs designed the Fellow's Building to the west of the Great Court in 1724. The hall and combination room were built opposite the chapel by William Wilkins between 1824 and 1828, together with the screening walls and gateway, which lay on the east of the Great Court, parallel with King's Parade.

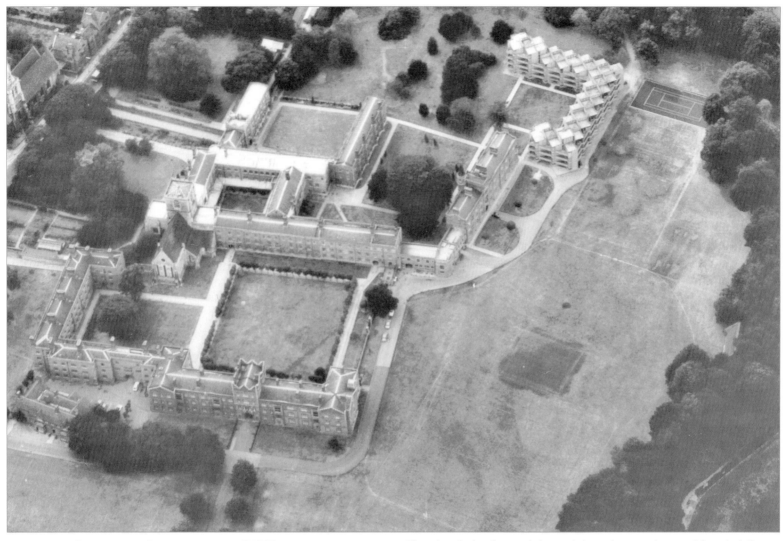

81 JESUS COLLEGE, CAMBRIDGE* (WSW)

Jesus College was founded by Bishop Alcock of Ely in 1496. He closed the Benedictine nunnery of St Radegund, which had stood on the site since the mid-twelfth century, and used the buildings as the basis for his new college. As a result, the college preserves almost the best example of a Benedictine nunnery in England.

The core of the religious complex was the twelfth-century nunnery church. To the right, the small nuns' cloister survives enclosed by the monastic buildings. The north (right) transept of the church lies left of a long range containing the nuns' dormitory or 'dorter' on the first floor, with the nuns' chapter house on the ground floor (both floors converted by Bishop Alcock into bedrooms for the students). At right angles to the dorter and parallel with the nave of the church on the north side of the cloister was the nuns' refectory and kitchen, the former converted by Bishop Alcock to the dining hall of the new college. On the west (top) side of the cloister, parallel to the dorter and at right angles to the west end of the church, lay the nuns' library and the abbess's apartments. The guest range of the nunnery became the college master's lodge, which abuts on to the west end of the church.

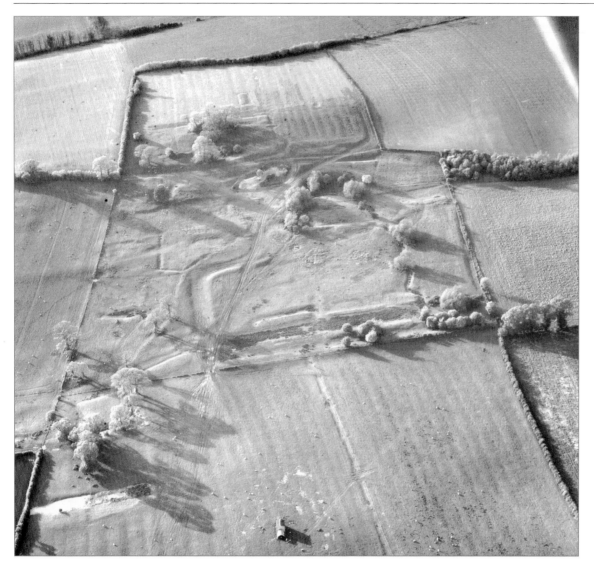

82 DESERTED MEDIEVAL VILLAGE, CLOPTON* (NW)

Like many other villages, Clopton fell victim to the low wheat and high wool prices which followed the Black Death and the economic recession of the mid-fourteenth century. Between 1500 and 1507, the village was cleared of its inhabitants and the open fields, the ridges of which still surround the site, were enclosed for sheep. By the 1550s, only three shepherds and their sheep lived in the parish.

There had been two manors at Clopton until 1444: one on the rectangular moated site (bottom left), the other at the main manor of Clopton Bury, which stood on the mound surrounded by a more oval moat (near the top right). The village street, now a wide hollow-way, connected the two sites, and goes on up the hill to connect the village with a main road, now only a hedge-lined footpath (running from right to left across the top of the photograph).

The stream, marked by pollard willows, ran down the hill to the right of Clopton Bury – the moat of which it also filled – to the mill, and its pond, which is marked by a clump of trees. To the left of the mill are two long, rectangular depressions, intended to be filled with water, which may have been fishponds.

The platforms left by the villagers' houses and the ditches which divided their properties are to the left of the hollow-way, between the first manor and the old main road.

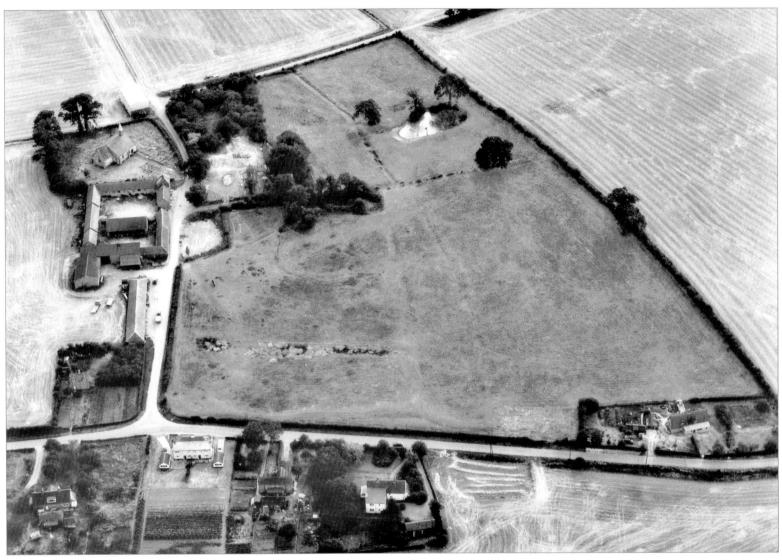

83 SHIFTED MEDIEVAL VILLAGE, WESTLEY WATERLESS* (SW)

This isolated church lying next to Westley Hall marks a likely focal point of the medieval village of Westley Waterless, the remains of whose houses, yards and lanes are probably marked by the ditches and faint earthworks in the pasture field to the right.

Westley Waterless had been carved out of Borough Green (to the east) by the tenth century, on a portion of the mother parish's arable and sheep pasture (no woodland was mentioned in 1086). There were never very many families here — usually about fifteen or sixteen — and the population level remained stable throughout the Middle Ages and after.

This was almost certainly because the local economy always appears to have included a significant proportion of sheep farming. This would have brought in enough income to keep the medieval holders of the manor happy, and would not have drawn new labour to the settlement in the early Middle Ages, or encouraged people to leave in the later middle ages, as an emphasis on arable farming might have done.

The modern village is dispersed, and it is possible that the medieval village was also polyfocal. Here there was neither desertion nor growth between 1086 and 1728, simply a shift in importance from one settlement site to others. The population has grown since then, and now stands at about twice its medieval average.

84 DESERTED MEDIEVAL VILLAGE, LANDWADE* (E)

Like Clopton, Landwade appears to have been enclosed for sheep, whose numbers rose from two hundred in the early thirteenth century to four hundred by 1450. Typical of deserted villages, the population here was always small – about fifteen households in 1327 – and the parish was owned by one person (the Cottons bought the estate in 1420). Unlike the owners of Clopton or Silverley, the Cottons continued to live at Landwade, where the nineteenth-century descendent of the manor house still stands, and continued to use the church, which also survives.

The large, regular moated site of the medieval manor house (now demolished) is in the north-east (centre left). It was fed by an artificial course from a stream (which enters top right). The stream continued round the top of the moat and down its left side to feed two watermills, which were there in 1408. The church lies just west of the moat.

A hollow-way just below the church, leading to a ford over the stream, is oriented in exactly the same direction as the churchyard and the moat and is also probably medieval. If the village of Landwade had once been planned, this regularity makes the hollow-way a likely survivor. The site of the village is not known for certain, but disturbed ground in the field below the hollow-way suggests that it lay there.

85 MADINGLEY HALL (SE)

Like many other minor gentry, Sir John Hynde, a lawyer, benefited from the enormous lands and buildings which went on sale after the dissolution of the monasteries. Among other properties, he acquired Anglesey Abbey and, in 1541, with the income from the abbey's estates, set about building himself a fine modern hall at Madingley, where he had lived for the previous twenty years.

The hall was set within a park enclosed from the common fields and which included part of the village street. Initially the south-east range was built, perhaps as a hunting lodge, in expensive red brick on footings of stone from Anglesey Abbey. The kitchen range, to the south, was built almost entirely of reused stone as it was out of the sight of visitors. At the end of the sixteenth century, Sir John's son built a long range on the north. Part of it has been demolished, but a large part of his building can be seen in this view, together with the fine loggia at ground-floor level.

Nothing is known to be left of Sir John's gardens. The view to the south-east of the hall was landscaped by Capability Brown in the mid-eighteenth century, and the north-east gardens were remodelled in the early twentieth century. The stables and gateway were also added in the eighteenth century.

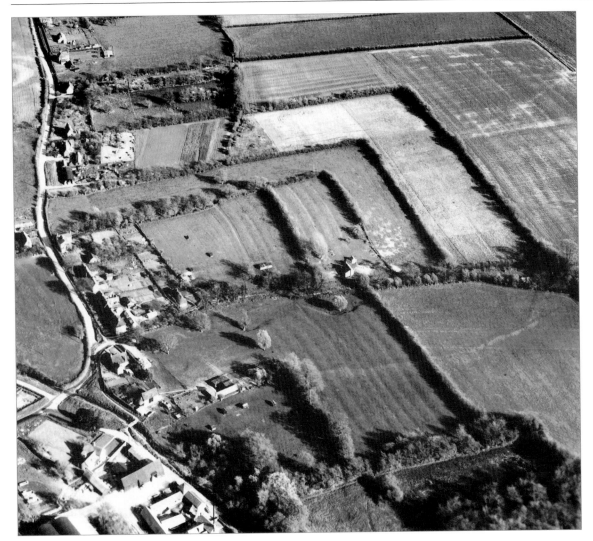

86 LATE MEDIEVAL FIELDS, BOURN (SE)

The large profits to be made from sheep farming encouraged many small peasant farmers in the later Middle Ages to negotiate with their neighbours to buy and sell land until several of their open field strips lay in a block. These could then be hedged and converted to sheep pasture, which, incidentally, preserved the ridges well.

This is exactly what seems to have happened at Bourn. In the centre of the photograph are two fields running down to a small stream. They contain ridge and furrow, and their hedges follow the curving reversed 'C' line of the medieval ploughlands precisely. These small fields with curving hedges are typical of late medieval fields, and they are in contrast with the later fields, the boundaries of which march over ridge and furrow, ignoring it completely.

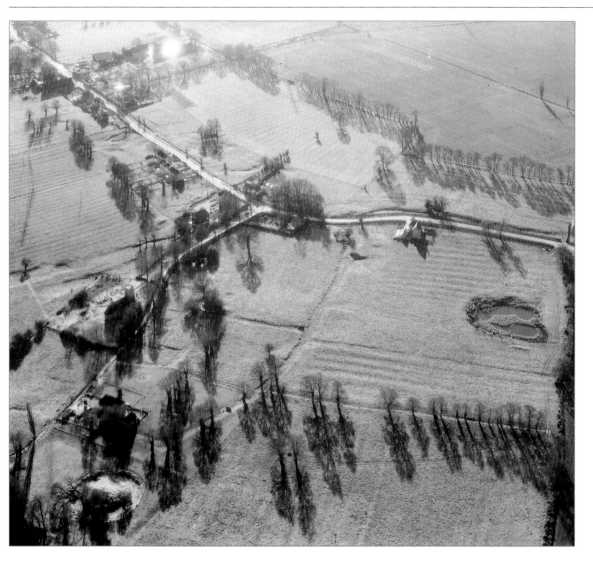

87 SHIFTED VILLAGE, KNAPWELL* (SW)

The medieval village at Knapwell lay to the north of the church. The road leading to, and past, the church was the high street, and originated as a minor road to Cambridge. The sites of houses and their properties can be seen between the old high street and a hollow-way, which lies parallel to it to the north. The field immediately north of the second hollow-way may also have carried properties, as it contains a few suggestive earthworks near the hollow-way. It is now covered in straight post-medieval ridge and furrow.

The manor house stood to the north-east of the church. A seventeenth-century farmhouse now occupies the site. West of the manor house (bottom left), is a small but wide circular moat. This is believed to be the site of a small castle built by the Abbots of Ramsey to protect their manor at Knapwell during the twelfth century. The church was situated on the village green, whose one edge was the high street. The other edge of the common was the field boundary to the south, which separated the cultivated fields from the green and formed a triangle with the high street on its northern side.

In the sixteenth and seventeenth centuries the road leading through Knapwell became increasingly important and people began to build their houses along it to benefit from passing trade. Gradually the old site of the village became depopulated, leaving the church isolated.

88 WIMPOLE HALL* (NNE)

The central section of this imposing house was built in 1640 on the site of the medieval manor house for Thomas Chicheley, a keen royalist and a man of fashion, and was further enlarged to its present size in the later seventeenth century. No house of this importance could be complete without an accompanying formal garden, and the foundations for much of the current parkland landscape at Wimpole were laid in the same period.

The medieval manor had stood within a deer park, which was situated largely to the north and west of the present hall. Arable land, divided into several large fields, covered most of the rest of the landscape, together with some enclosures and woodland, and was farmed by local people who lived scattered about the parish in several small hamlets.

Hamlets approximately 300 yards south and south-west of the hall, and another around the church, were moved to make way for Sir Thomas's gardens and park. By the early eighteenth century huge formal gardens included large rectangular water gardens immediately south-west of the hall, and four avenues of elms radiated out from the house. The ornamental lakes to the north of the hall were remodelled in the mid-eighteenth century, at the same time that the folly was erected on a hill beyond them. Much of these Restoration gardens was swept away in 'natural' park landscaping in the mid-eighteenth and early nineteenth centuries.

The Home Farm, to the north-east, was constructed in the early nineteenth century when improvements in agriculture became a gentlemanly pursuit.

7: TUDOR AND STUART CAMBRIDGESHIRE

c. AD 1550 – 1700

The end of the medieval period was marked by the increasing individualization of the landscape through two general processes – the continuing enclosure of fields and commons by yeoman farmers on the one hand, and the personalization of the landscape through the creation of country houses and impressive gardens on the other.

The period began with the dissolution of the monasteries. Between 1536 and 1539, all monastic houses in the country were closed and their assets seized by the Crown. The monastic estates and buildings were sold off, often to the highest bidder. For example, Sir John Hynde, a local lawyer and Member of Parliament, acquired Anglesey Abbey and its lands in 1539 and made a fortune as a consequence, while the earls of Bedford gained 20,000 acres of fenland from Thorney Abbey. Sometimes land was sold to the local farmers who had previously leased monastic land to enlarge their holdings and had thereby made enough money to buy the freehold. In the landscape the effects can be seen in the ruins of the monasteries, pulled down for building stone or refurbished as fine houses; and also in the country houses and emparked lands of those who profited from the Dissolution.

The new country houses were built in many parishes which had never previously had a resident manorial lord. They were often built in locally made red brick – the earliest documented brick kilns in Cambridgeshire were at Papworth St Agnes in the 1530s. Sir John Hynde built a large house at Madingley in 1541 using materials from Anglesey Abbey for the less important parts of the building, and enclosing part of the village fields for his park and gardens. At Childerley, Sir John Cutts built a new house in about 1600. As his new formal garden was too close to Great Childerley village for his liking and as he wished to create a park, he removed the remaining villagers to other parts of his estate.

In the fenland the division of monastic land between several owners meant that the new owners were often unwilling to take responsibility for the drains and ditches, the maintenance of which was essential for flood prevention and control. Increasingly frequent flooding throughout the sixteenth century made the need for action more and more urgent, and in about 1630 a Dutch engineer, Vermuyden, was brought in to draw up a plan for draining more than 1,300 square miles of undrained fen. He divided the fenland basin into three levels – the Cambridgeshire Fens generally fall into the Middle Level. The first great drain (the Old Bedford River) which took water from the River Ouse near Earith to Denver near Downham Market was cut in about 1630 – it was 21 miles long and 70 feet wide – a massive undertaking.

However, the new cut was soon found to be insufficient to carry the quantity of water which drained into it, and the New Bedford River was cut parallel to its predecessor in 1651, with a large floodplain between the two cuts to absorb floodwater. Initially there were great improvements and huge profits. However, the peatlands began to sink as the water was removed from them and first horse-mills and then windpumps were needed to lift the water from the field drains into the main drains, which carried the water away.

In the uplands the enclosure of fields and commons which had begun in the later Middle Ages continued as farmers began to increase the number of livestock on their farms. Dairy farming became more important and the large roughly rectangular fields of seventeenth-century enclosure can be seen in many parts of the county. The growing economic independence of many small farmers was reflected in their struggles to survive the competition of the larger estates, and was symbolized in their determination to withstand the dilution of Protestantism which gathered pace in the early seventeenth century. Cambridgeshire was a centre for religious dissent – Cromwell's 'lovely company . . . of honest, sober Christians' came from this county – and, of course, Cromwell came from a local family. The civil war broke out in the summer of 1642, and the county prepared itself for war by refortifying Cambridge Castle and building forts at Earith and at Horsey Hill, near March.

89 THORNEY ABBEY* (SE)

The parish church at Thorney is all that remains of a once powerful and wealthy Benedictine monastery built on a small island surrounded by waterlogged peat fen. It was founded by the first Abbot of Peterborough as a retreat in the seventh century, then destroyed by the Danes in raids in the ninth century and refounded in 970 in the great flowering of Benedictine monasticism, which saw new abbeys at Peterborough, Crowland, Ramsey, Ely and Chatteris. The abbey was dissolved in 1539.

After the Dissolution, Thorney Abbey was granted to the Earl of Bedford and the site was left to decay. The successful draining of the fens in the seventeenth century appears to have stimulated immigration to Thorney, and the abbey was pulled down to make way for homes for the incomers. The surviving part of the nave of the monastery church was converted into a parish church, with a new west front. (The east end and transepts were added in the nineteenth century.) The green was laid out to the south of the church over the site of the cloister and other monastic buildings, and large houses were built around it, reusing stone from the monastery.

The confused and irregular property boundaries of the block of houses lying to the north of the church (bottom left), as well as the fact that the block is entirely surrounded by roads, suggests that a second green may have been laid out here.

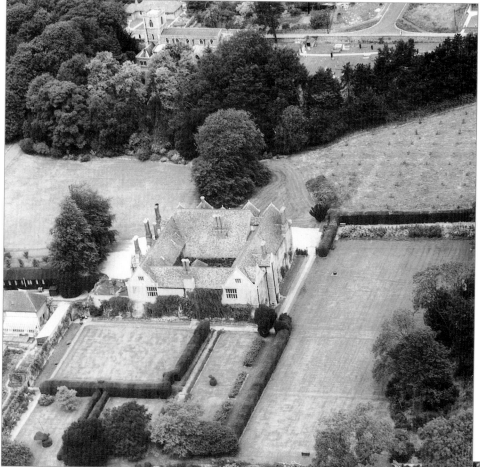

90 SAWSTON HALL (NNW)

The current hall was built in the late sixteenth century to replace a manor house destroyed by fire, and elaborate gardens were laid out to the east of the hall at the same time. The high terraced walk aligned to the north front of the hall is visible in this view.

The parch marks in the grass inside the garden reveal the layout of small geometric planted compartments separated by regular paths. These are entirely typical of the layout of an Elizabethan garden, which combined the small-scale formality of garden plots with the large-scale grandeur of surrounding earthworks.

91 THE MANOR HOUSE, PAPWORTH ST AGNES (S)

The manor house at Papworth St Agnes, enclosed by a medieval moat, was built in the sixteenth century. At the same time a garden was laid out to complement it, and the eastern side of the moat was filled in. A substantial bank and ditch was built to the east (left) of the house to define the new garden, with prospect mounds at the corners from which the outside world could be viewed.

However, only part of the house was completed and it is likely that the garden is also incomplete. In the seventeenth and eighteenth centuries the garden contracted towards the house, and the eastern part of the Elizabethan garden has been incorporated into pasture.

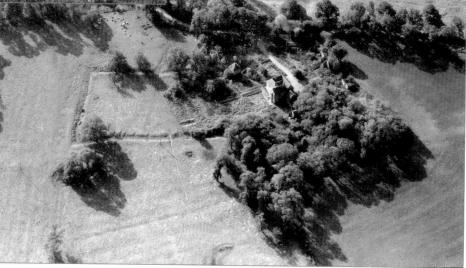

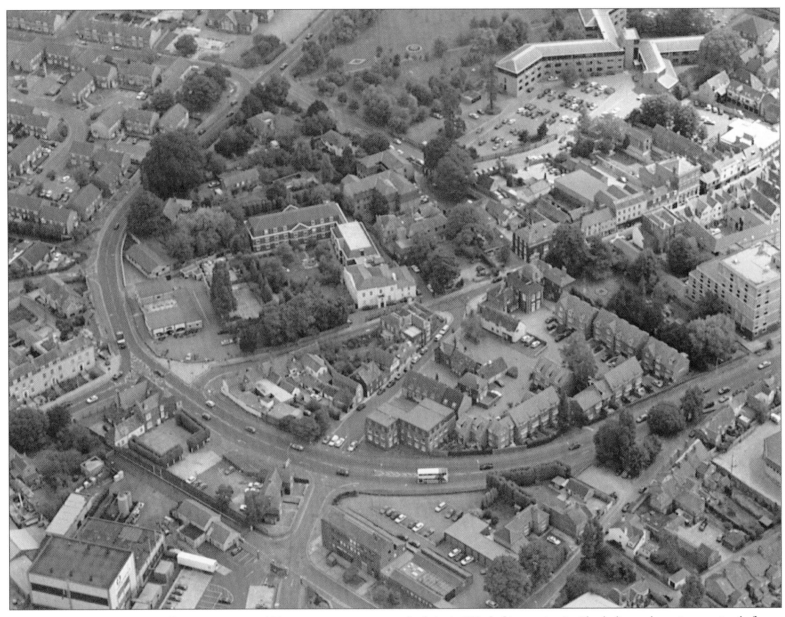

92 CROMWELL HOUSE, HUNTINGDON (E)

Oliver Cromwell was born in 1599 in the white house which stands near the top of the High Street in Huntingdon. It stands on the site of an Augustinian friary, which was founded in the early thirteenth century. By the time the Cromwells acquired the house, shortly after the dissolution in 1538, the friary was in ruins. They built a new house, incorporating the floors and lower walls of some of the friary buildings. The Cromwells sold the property in 1631. Only the footings of the present house are late sixteenth century and contemporary with the home which Cromwell would have known, as it was almost entirely rebuilt in *c.* 1830.

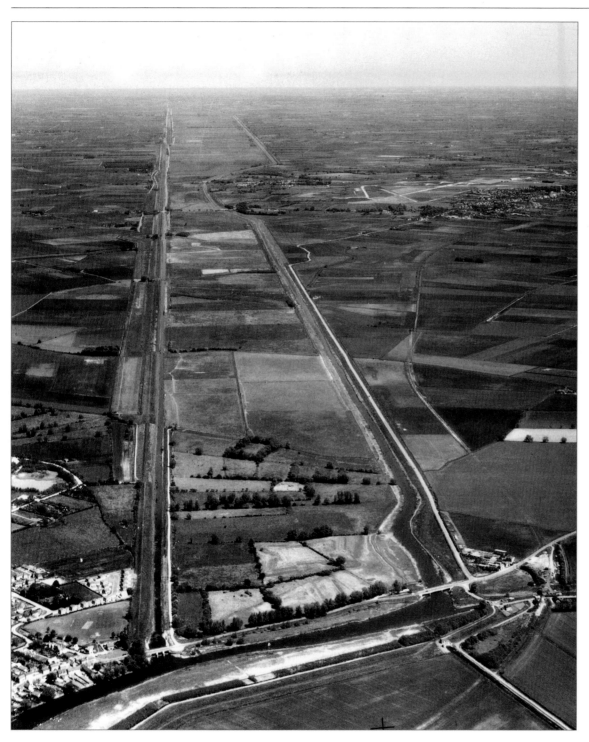

93 THE BEDFORD LEVEL*
(NE)

In 1630 the Fourth Earl of Bedford, who owned 20,000 acres of undrained fen in Thorney and Whittlesey, formed an agreement with thirteen other investors to drain the southern fens to create 'pleasant pastures of cattle and kyne'. This was the origin of the area known as the Bedford Level. The 'Adventurers' (so called because they 'adventured' or risked their investment capital), employed Vermuyden, a Dutch engineer, to manage the drainage scheme. During 1636–7 he oversaw the digging of a huge cut, 21 miles long and 70 feet wide, now called the Old Bedford River, to carry the waters of the River Ouse straight out from Earith to Salter's Lode near Denver. This is the canal running up the left of the photograph.

The work was initially successful, but it soon became clear that another cut would be necessary. In 1651 the New Bedford River was cut as the main drain between Earith and Denver. This runs up the right of the photograph, parallel to the Old Bedford River, which was demoted to draining the local fenland. A wide strip of land – the Washes – was left between the two cuts, partly to take surplus water when necessary and partly to enable the old and new rivers to continue to drain upland and fenland as one huge stream in times of flood.

This massive pair of earthworks, dug entirely by hand, must rank alongside the Seven Wonders of the World as a monument to human achievement.

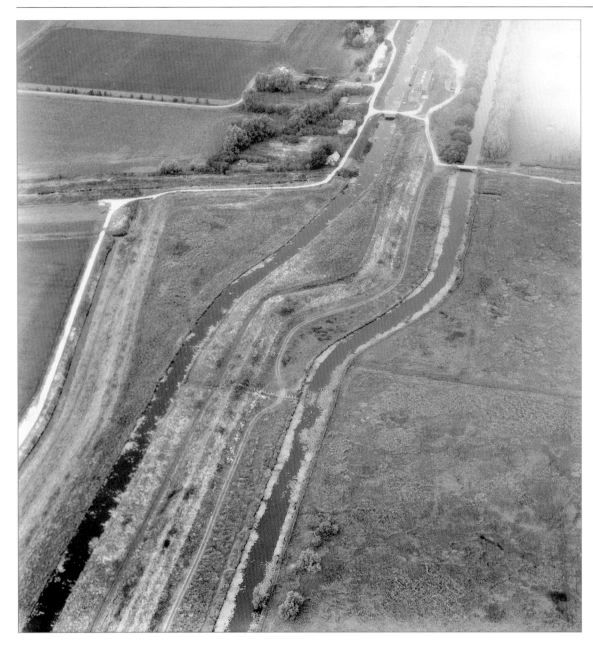

94 WELCHES DAM* (NW)
Seventeenth-century fen drainage is
magnificently fossilized by earthworks at
Welches Dam, seen here. The Old Bedford
River, cut by 1637 to take the waters of the
River Ouse straight out across the fens to
the Wash, enters the bottom of the
photograph as the right-hand Inner Channel.
Its original course leaves the top of the
photograph as the left-hand Outer Channel.

In 1651 the Old Bedford River was
demoted to draining the newly reclaimed
peatlands to the south and acted as an
occasional overflow channel for the New
Bedford River, which had been cut 800
yards to the east as the new main drain. In
about 1651, Edward Welch built the dam to
allow the new Outer Channel to absorb the
waters of the Forty Foot Drain as part of its
new local drainage function. The dam's
rectangular banks can be seen on the
photograph, interrupting the original line of
the Old Bedford River. The Forty Foot
Drain enters the photograph at the bottom
left, continuing in a straight line to join the
Outer Channel, immediately north of
Welches Dam.

The right-hand Inner Channel, still called
the Old Bedford River, was made by
diverting the waters of the Old Bedford
River around the outside of Welches Dam
into a new cut – the Thirty Foot Drain –
which simply replaces, and runs parallel to,
the original course of the Old Bedford
River, north of Welches Dam.

The huge bank between the Inner and
Outer Channels created a catchwater
between the old and new rivers in times of
flood, while the lesser bank west of the
Outer Channel prevents local flooding if the
Outer Channel breaks its banks.

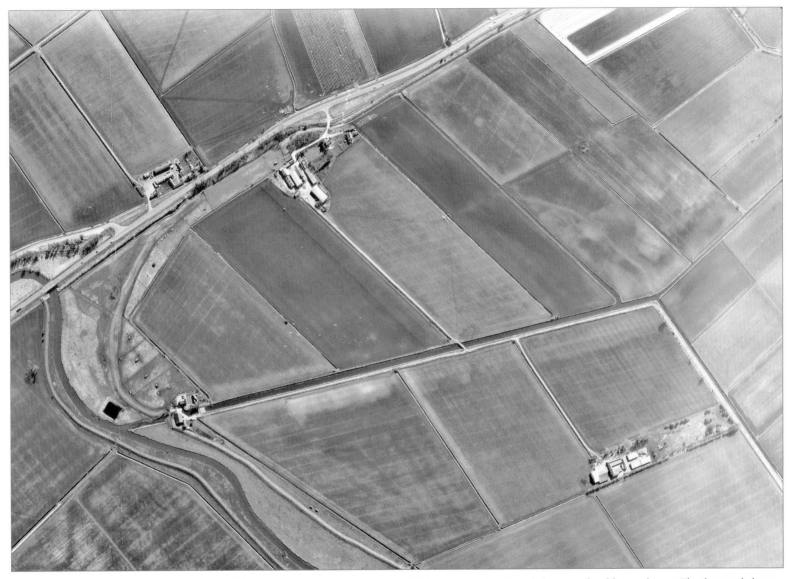

95 FENLAND PUMPING STATION (E)

The earliest drainage engines in the fens were wind-powered, supplanted first by steam, then by diesel and later by electric pumps. They were needed to lift the water into the major drains, which increasingly lay higher than the sinking peatlands. Although the power driving the pumps has changed, the geography of drainage has not. The photograph shows minor drains around each field feeding into connecting drains, which run along the fields. These connecting drains run into main drains, which are then emptied via a pump into (in this case) the River Ouse, which takes the water out to the Wash.

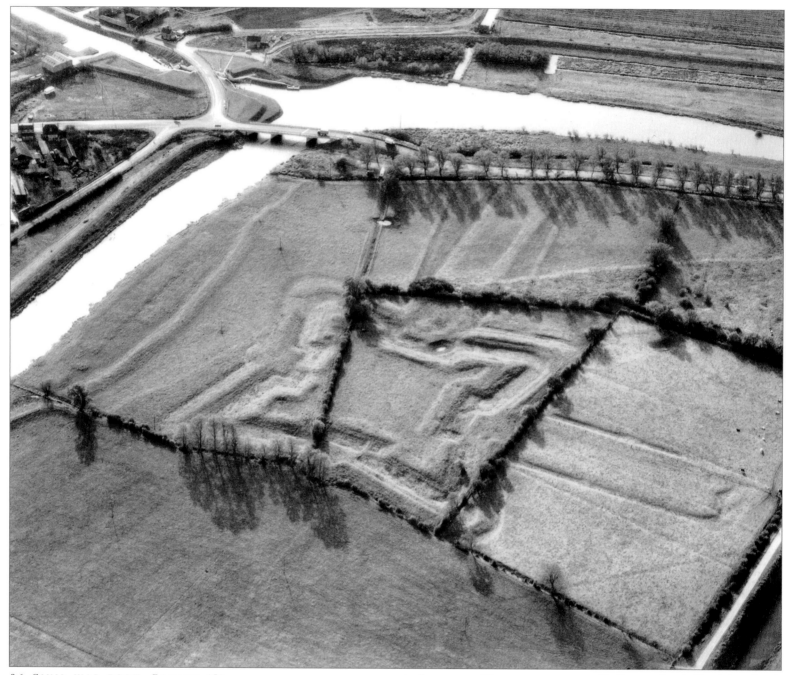

96 CIVIL WAR FORT, EARITH (S)

One of the best-preserved civil war forts in England, this magnificent example at Earith was built by parliamentary forces to guard the crossing over the River Ouse (on the south) and the Old Bedford River (on the east). The designers may have been Captain John Hopes and Richard Clamp.

The fort is roughly square and covers nearly 2 hectares. It has angle bastions at the corners to allow cannon and firearms to cover every possible direction of attack. The whole earthwork is strongly defended by a large rampart with internal and external ditches. Any attacker would have needed to cross the outer ditch, a rampart and then an inner ditch before reaching the rampart of the fort. The two parallel ditches to the west – more than 80 metres long – may have been designed as an outwork to defend the fort from a land-based attack.

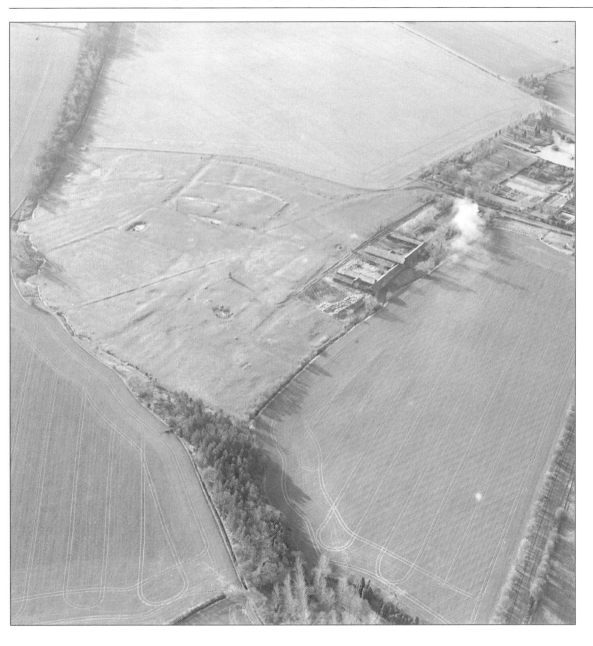

97 DESERTED VILLAGE, CHILDERLEY (SSW)

The photograph is dominated by the deserted earthworks of Great Childerley village. The manors in Great and Little Childerley were bought by Sir John Cutts, under-treasurer and councillor to Henry VII, in 1508–9. He soon depopulated the parishes for sheep, and by 1524 there were only eighteen families left in both parishes.

The site of the medieval village is bounded by the ridge and furrow of its fields. A broad hollow-way encloses most of the site to the north-west and south-east. Within the rectangle formed by the hollow-way is a rectangular enclosure, also defined by ditches. These are the remains of the manor house, whose gated moat was mentioned in 1411, together with the causeway which led across the moat on the western side. The church stood near the small clump of ancient trees nearer the north-eastern corner of the modern field. It was still in use in 1540, but had been closed by 1552. By 1639 it had been converted to a brewhouse and stable.

Sir John built himself a new house and garden to the north-west of the deserted village. The southern parts of the garden can be seen on the far right. It is square and moated, with a high internal bank which rises to the south as the land falls away. Originally it would have been divided internally by paths into smaller knot gardens, mazes and arbours, but these have not survived. The irregular lake on the western side of the garden ensures that the moat remains filled with water, as the ground slopes away in that direction as well.

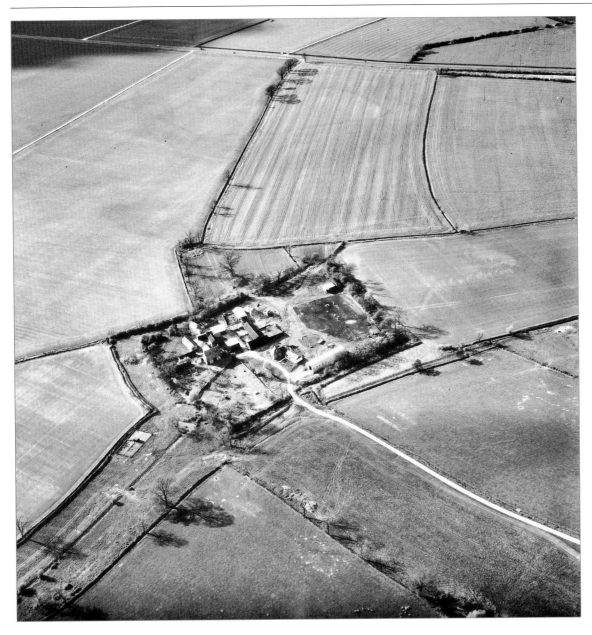

98 CAXTON PASTURES (NW)

The moated farmhouse at Caxton Pastures was built during the Middle Ages where a narrow strip of pasture (bottom left) – which ran up from the village along a stream-filled valley – widened into the sheep common. Much of the rest of the common has been enclosed, but it appears to have broadened out towards the right. The Caxton share of the common was bounded in the north by the Roman road (a parish boundary), which runs along the top of the photograph, and the straight western parish boundaries, the zigzag course of which runs down from the road to the bottom left.

Medieval ridge and furrow in the field north of the farmstead indicates that this land was brought into cultivation during the land hunger of the early Middle Ages. It almost certainly reverted to pasture after the mid-fourteenth century.

During the seventeenth century the enclosure of strips into fields, which had begun during the later Middle Ages, continued. There is much evidence of an increase in livestock farming in Cambridgeshire during this period, and farmers began to want to have their animals in separate flocks so that they could control breeding and disease. The field to the north of the farmhouse is typical of these enclosures. It is larger than the medieval fields enclosed at Bourn, but its eastern boundary nevertheless follows the medieval cultivation.

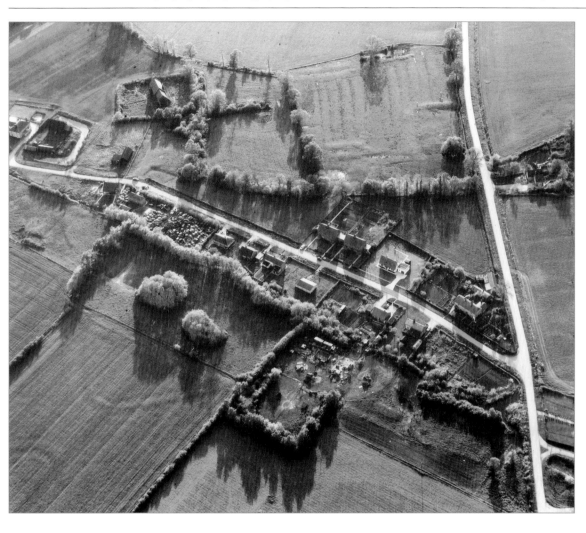

99 DECAYED VILLAGE, EAST HATLEY* (W)

The medieval village at East Hatley lay on either side of a funnel-shaped green which led to pasture on the high clays to the north at Hatley Wilds. The outline of the green is still marked by hedges, although the modern village lies within the green. Along the sides of the green, the church and some moated sites (some marked by hedges) can still be seen.

The reasons for the village's decline were not dramatic but gradual. The heavy clay soil, the poor weather and the economic recession of the later Middle Ages all contributed to the decline of the village from about twenty-three households in 1347 to nine in 1563, as people gradually moved away to land which was easier to farm. The two manors in the parish both came into the ownership of the Castell family in the 1490s. They encouraged enclosure of some common field land for sheep pasture, leaving only those peasants with flocks of sheep and cattle with an incentive to stay. By 1661 the whole parish had been enclosed and divided into ten farms. Farmers began to build farmhouses outside the village on their farms, and as holdings were amalgamated the number of farms declined to six in 1801. The village virtually disappeared and has only been saved by increased settlement in the twentieth century.

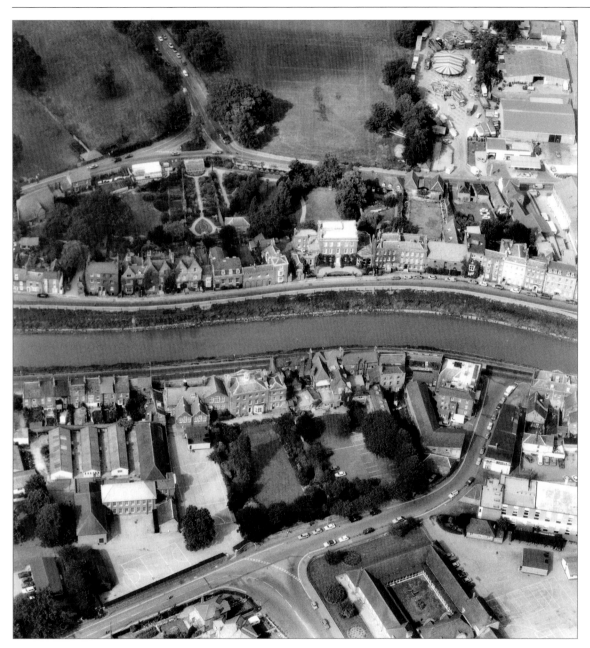

100 EIGHTEENTH-CENTURY COMMERCIAL CENTRE, WISBECH* (NW)

Wisbech occupies an important position at the intersection of the main road from King's Lynn to Spalding and the River Nene. A Saxon market marked the beginning of its commercial life and had grown to three market-places and a fair by the Middle Ages. The draining of the fens to the south led to improvements in the outfall of the River Nene to the sea, and by the 1720s the town had become a thriving port, exporting rape-seed oil and oats, and importing coal.

Fine Georgian town houses were built along the banks of the River Nene near the port for the merchants at Wisbech, reflecting their and the town's wealth and status. By 1772, William Cole, the Cambridge antiquary, commenting on Wisbech, said '. . . the buildings were generally handsome, the inn we stopped at (the Rose and Crown) uncommonly so . . . but the bridge, stretching Rialto-like over this straight and considerable stream, with a good row of houses extending from it, and fronting the water, beats all.' These houses can be seen to best advantage on the west bank – the North Brink. Their elegance and grandeur are enhanced by the size of the River Nene as it passes by to the sea.

8: THE EIGHTEENTH CENTURY

AD 1700 – 1800

The eighteenth century was a period of growing economic prosperity. Greater yields of crops and livestock produced as a result of improvements in agriculture from the late seventeenth century onwards produced a good return, particularly for the owners of large estates who benefited from economies of scale. Country houses were often rebuilt or refurbished in this period in the calm and symmetrical classical styles which reflected the pervasive belief of the time that the discovery and application of natural laws would enable men to create a well-ordered society. The formality of the gardens created at Gamlingay were another expression of this belief. Later in the century, gardeners like Capability Brown (who worked on many Cambridgeshire estates) created 'natural' landscapes with long views,

101 Commercial End, Swaffham Bulbeck (WSW), an eighteenth-century large-scale trading enterprise, exporting local crops and importing coals, wine, salt and other commodities.

lakes and stands of trees, the perfect naturalism of which symbolized the perfection of a natural society based on natural laws. Houses, parks and gardens were created or rebuilt across the county from Hatley St George in the west to Chippenham in the east, reordering vast acreages which had previously been villages and fields.

There were improvements in transport. Virtually every major road in Cambridgeshire had been turnpiked by 1800 and income generated by charging travellers on the turnpike roads was spent on improving and maintaining the road network. The rivers too were recognized as an important element of the transport system. The River Cam, for example, was treated as a turnpiked waterway, while there was also investment into the dredging and straightening of the River Nene to combat silting at Wisbech. The development of a transport infrastructure meant that commerce flourished. The beautiful Georgian terraces lining the Brinks – the banks of the River Nene – at Wisbech were built for the successful merchants whose ships docked nearby. At Commercial End in Swaffham Bulbeck an eighteenth-century trading house and its associated specialist warehouses grew up near the end of Swaffham Bulbeck Lode.

Old and new enterprises developed. In the fens, decoy ponds were built and huge numbers of ducks were sent to London until well into the nineteenth century to satisfy the London market for game, while the development of horse-racing at Newmarket led to the establishment of stud and racing farms outside the town.

In Cambridge, Downing College was founded towards the end of the century after a lengthy legal wrangle over the estate of Sir George Downing, who had built the now demolished house and gardens at Gamlingay. Its plan and gardens reflect the country estates from which its income was derived.

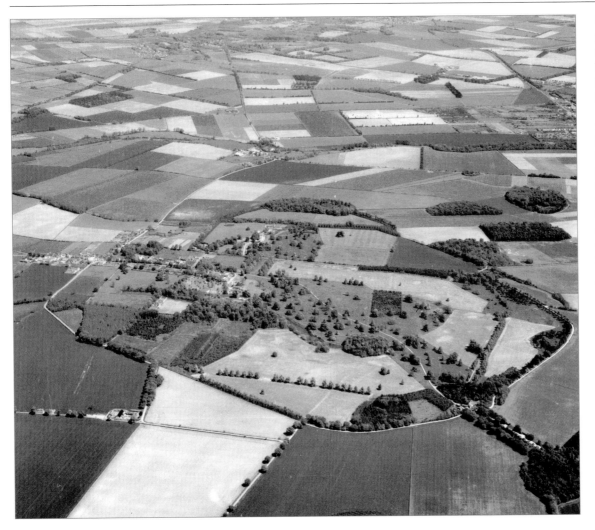

102 EIGHTEENTH-CENTURY PARK, CHIPPENHAM (ENE)

In 1696 a large estate at Chippenham was bought by Edward Russell, who later became Lord Orford (celebrated for his trip by boat around Whittlesey Mere).

The park was laid out between 1702 and 1712 over a large tract of countryside, including in its extent some of the common fields and a large part of the common pasture of the village. Its roughly oval outline can be seen to the south (right) and west (bottom), following the roads and tracks which show up as a white line enclosing irregular shapes inside the park, contrasting with the rectangular layout of the fields outside. The northern (left) and eastern (top) sides of the park follow the hedgeline, which continues the line of the road from the southern corner.

The road which winds through the park from middle left to bottom right was once the village high street. Where it passes the site of the hall at the northern edge of the park, twenty-five houses were demolished, and a small estate was built for the displaced workers along the road which leads eastwards (towards the top of the photograph). Inside the park a new landscape was created, including a long canal set among scattered clumps of trees to create a 'natural' effect. Some of this landscape is still visible, although part of the park has now been divided into farmland.

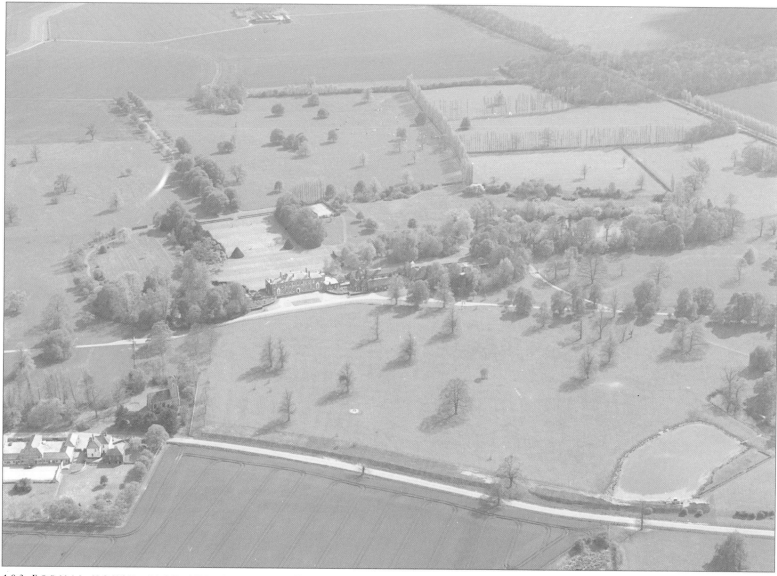

103 FORMAL HOUSE, PARK AND GARDENS, HATLEY ST GEORGE (SW)

Hatley Park incorporates almost a third of the entire parish of Hatley St George. The park contains mostly the informal pasture ornamented by clumps of trees which became so popular in the mid-eighteenth century. The present landscape was created in the century between about 1640 and 1740.

The house was built in two stages: a gentleman's residence was built by 1641 and survives as the central portion of the present house; by 1753 it had been turned into a country house with the addition of formal wings.

The park, which had been arable land until this time, was enclosed and given over to pasture, preserving much ridge and furrow. The nineteenth-century park bank, which runs along the road near the bottom of the photograph, isolated the church from the few villagers who still remained. A formal garden which had been laid out to the south of the house has not survived, apart from a few ditches, as it was swept away in the 'natural' and informal landscaping which accompanied the extension of the house in the 1740s and '50s.

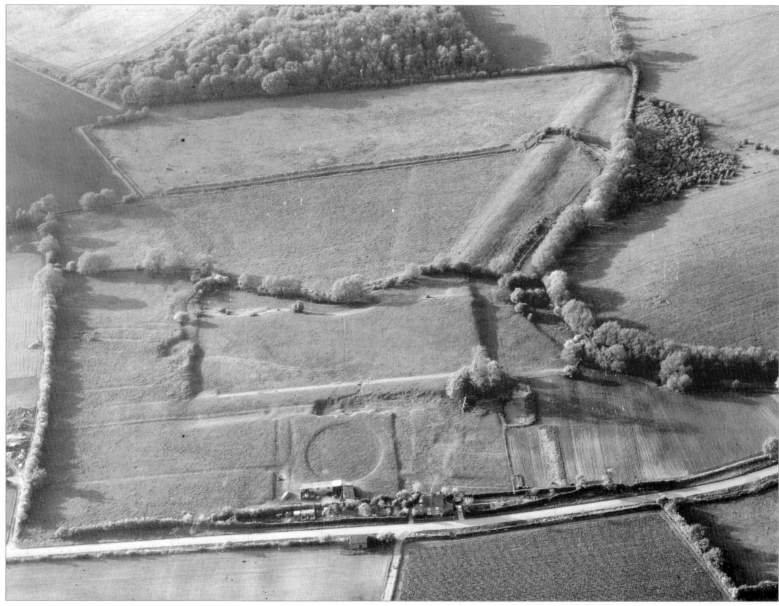

104 FORMAL GARDENS, GAMLINGAY (N)

In 1711, Sir George Downing inherited large estates in Cambridgeshire and decided to build himself a new mansion and garden at Gamlingay. The house was demolished in 1776, but the earthworks of the garden are still startlingly clear from the air. The land reverted to pasture and preserved an early eighteenth-century garden, the original layout of which had never been altered.

The circular depression within a square near the road was once a lawn within a gravelled drive. The narrow rectangles surrounding this entrance are the remains of the main block and wings of the house. To the left and right of the wings of the house were small enclosed gardens (left) and stables and kitchen gardens (right).

Behind the main block of the house lies a long, narrow terrace overlooking the valley to the north, into which the garden descends. Ramps at either end of the terrace lead down into a wide rectangular garden, which in turn leads down into a narrow terrace alongside a huge trapezoidal lake, now often dry, as in the photograph. In the centre of the lake was a small island.

The substantial bank which forms the right side of the lake dammed the waters on the sloping side of the valley and allowed the construction of a series of canals, which ran up the right side of the bank towards the house.

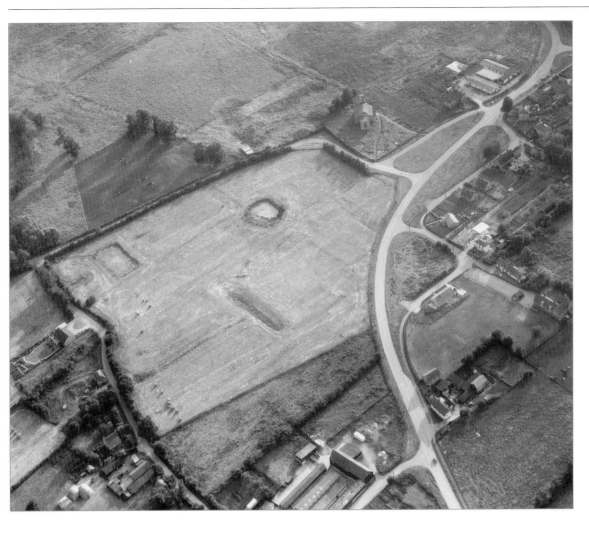

105 RUINED GARDENS, DRY DRAYTON (WSW)

Part of Dry Drayton village was enclosed by a hedge between 1565 and 1580 to create a garden around the recently rebuilt manor house and – ignoring the curve of the new main road built in 1968 – it can be seen how this park cuts across the village streets and lanes, which have been diverted to go around it. This house and its outbuildings were refurbished at the beginning and at the end of the seventeenth century.

The long, narrow water-filled ditch in the centre is the south-eastern end of the moat of the medieval manor of Crowland Abbey, which the new mansion replaced. The rectangular outline of the rest of the moat can be seen just above it – it has been altered, probably to become a watergarden for the new house. The site of the new house lay on the rectangular platform to the left of the ditch.

The rectangular subdivisions of the emparked land as well as the geometric pond at its south-east (bottom left) corner are all remnants of the sixteenth- and seventeenth-century gardens.

The house was demolished between 1817 and 1831, and was replaced by a farmhouse, the confused earthworks of which are situated immediately south of the moat. The gardens were abandoned, and only Park Road along the eastern side of the park commemorates what the field once contained.

106 DOWNING COLLEGE, CAMBRIDGE* (NNW)

This college was endowed in the will of Sir George Downing, who died in 1749 (and who built the extraordinary gardens – now ruined – at Gamlingay). His heirs contested his will, and it was not until 1800 that the college was formally founded.

The nineteenth-century architect ignored the traditional Cambridge college plan. Instead, the new college echoes the classical style made popular during the eighteenth century by such architects as Vanbrugh and Gibbs. The generous central square in front of the college, which measures 300 feet on each side, forms the focal point of the design. Separate symmetrically arranged blocks of buildings, linked by screen-walls, faced each other across the quadrangle. The projecting wing at the front of the left-hand range of buildings contained the scholars' hall and kitchen. The projecting wing to the right-hand range was built as a residence for the master of the college. On either side, behind the hall and the master's lodge, were ranges containing the students' and fellows' lodgings, and in the centres of these ranges a residence was built for the Professor of Law (left) and the Professor of Medicine (right).

The north-western block, which was also built in the classical style and which unifies the nineteenth-century design, was not built until the mid-twentieth century.

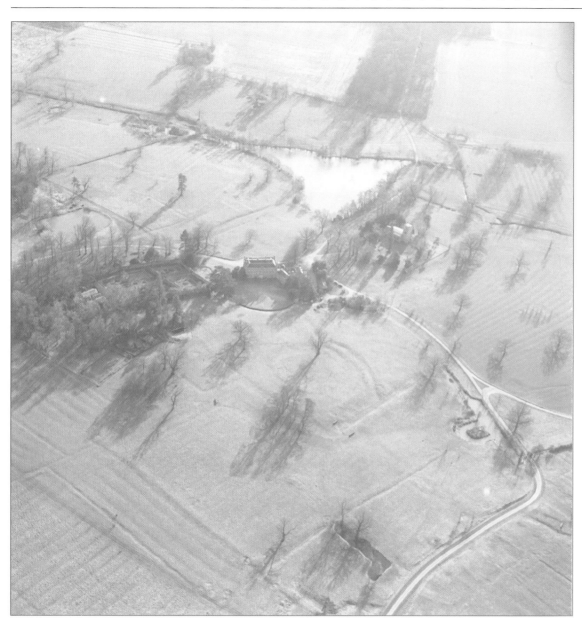

107 CROXTON PARK (SE)

Croxton was always a dispersed parish, the inhabitants of which lived in scattered farmsteads and hamlets. One such hamlet lay to the east of the small parish church. The hollow-way which formed its main street can be seen to the east of the church running from north to south, and the rectangular platforms along it are those which once carried the houses of its inhabitants. The ditches which separate the platforms were the boundaries between properties.

Another small settlement can be seen along the road which leads to Croxton Hall: a moat on the left of this view and another moat near the bend in the road are probably medieval, and were built to embellish the houses around which they were cut.

In the mid-sixteenth century the estate was bought by Dr Edward Leeds, who enclosed some arable land for his park. The curious circular enclosure with a central pond and the rectangular ditches lying outside it, which survive in the grassland west of the house, may be part of the formal gardens which successive owners laid out after the 1760s.

The park and gardens were remodelled after enclosure in 1811. Formality gave way to informality, and 'nature' took the place of artifice, so an entirely unnatural 'natural' landscape was created, of parkland ornamented by carefully placed clumps and belts of trees. At this point it appears that the hamlet to the east of the church and hall was finally swept away, partly lost under a large 'natural' (and therefore irregular) lake, while a kitchen garden was built to the north of the hall.

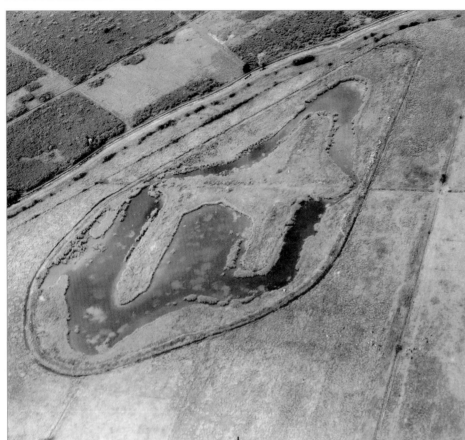

108 AND 109 DECOY PONDS AT WICKEN AND WHITTLESEY

Decoy ponds were introduced into the fens in the early seventeenth century by the Dutch engineers who supervised the fenland drainage. Their name is taken from the Dutch *eendenkooi*, which means a trap for ducks. They were intended as a replacement for the many meres and lakes where wildfowl had always been trapped. During the later eighteenth century, many were lost as the fens reflooded (windpumps were unable to keep the shrinking peats dry), although some continued to be used between October and March for sporting shoots and to supply the London markets. Holme Fen decoy, for example, took three thousand ducks in only seven days in 1876.

Wicken decoy pond (108) is an early example, as its irregular shape shows. The long arms or 'pipes' which branch out from the main pond were covered by nets hidden in the reeds and trees which fringed the banks. A dog or tame decoy duck lured the wildfowl on to the pond and then into the nets, where they were trapped and killed before being boxed for market.

The pond at Whittlesey (109) was made at some date after the River Nene was straightened in 1728. Its symmetrical shape suggests that it was made later than the Wicken pond, and that it may have been intended primarily for sporting rather than market use.

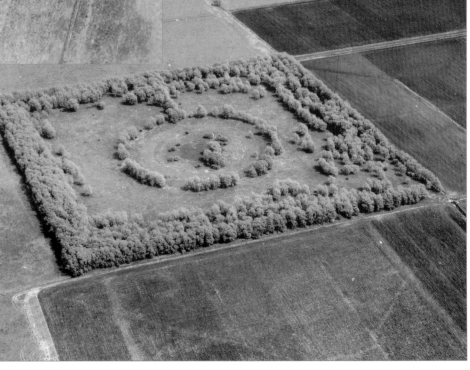

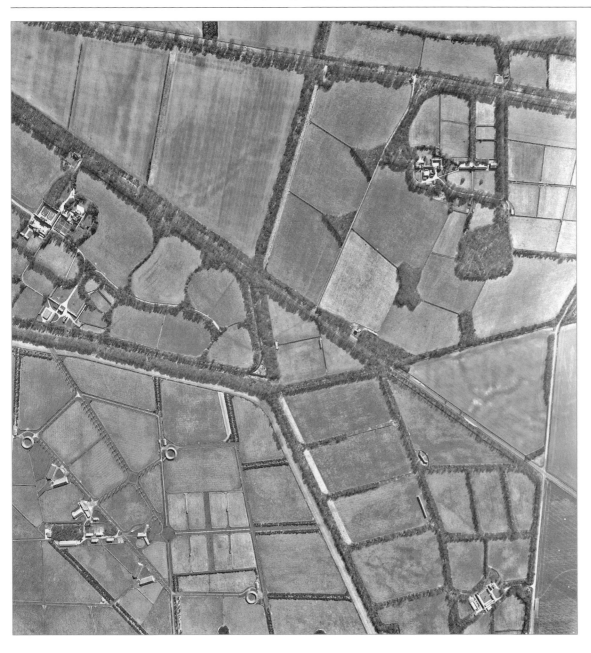

110 STUD FARMS, NEWMARKET HEATH (SE)

There has been racing on Newmarket Heath since the early seventeenth century when the site was patronized by the great sporting king, James I. The importance of training studs near the racecourse only became clear in the mid-eighteenth century, when the Duke of Cumberland established a private stud at Newmarket, and, from the 1780s, public trainers began offering their services to racehorse owners – a new and extremely profitable industry had been born.

Here, in Swaffham Bulbeck and its neighbouring parishes, farmers were able to take advantage of their proximity to Newmarket and the dry chalky heathland along the Icknield Way to develop their racing studs on land which they enclosed from open pasture. The regular plan of the studs with their stables, trainer's house and paddocks echoes the regularity of the enclosure landscape. Straight lines of woodland clumps and belts of rapidly growing trees gave shelter to the paddocks and training stables, while horses were exercised on the open heathland nearby. The National Stud lies in the bottom left-hand corner of the photograph.

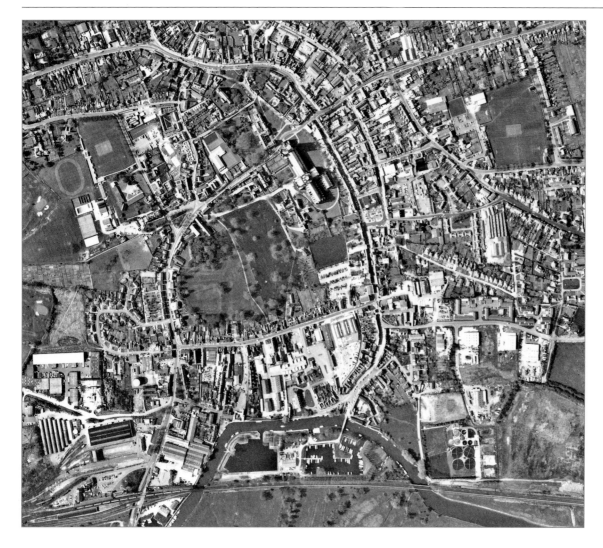

111 THE QUAY, ELY (NW)

The quays at Ely were initially developed in the Middle Ages by the monks from the abbey who reclaimed and built up the marshy sides of the river to make formal wharves. They also created several subsidiary cuts, which led north-west off the main stream and allowed more boats to land their goods away from the thoroughfare. This was done partly to encourage trade to the town, from which the abbey benefited through rents and tolls, and partly to facilitate traffic between the abbey and the outside world. Most have disappeared; however, the line of Broadhythe is preserved in the modern street which leads to the Quays. General and specialist warehouses and industrial buildings grew up along the waterside.

Waterborne trade was an important element of commercial life until the advent of the railways, which came into Cambridgeshire from the mid-nineteenth century. Although water continued to be cheaper than rail for transport, the barges could not compete with the speed, scale and complexity of railway communications. In many places the barges and wherries had disappeared within a few years of the railways being built. The commercial traffic on the river has given way to pleasure craft, and a small marina has been established on the south-eastern bank of the river to cater for this trade.

9: THE NINETEENTH CENTURY

AD 1800 – 1900

Landscape change began to gather pace from the late eighteenth century onwards. The improvements in crops and livestock introduced during the Agricultural Revolution were an incentive, particularly to farmers with significant acreages, to redesign the field systems of their parishes. Between 1780 and 1830, especially, there was a rash of Acts of Parliament in parish after parish which allowed the communally farmed open fields to be swept away. In their place, rectangular fields were laid out. The owners of agricultural land were able to concentrate their holdings in one place, and often built new farmhouses outside the village in the middle of their new fields. Now farmers were able to sow new strains of grain or improve their breeds of sheep and cattle without the risk of dilution from their neighbours, so considerable profits were made.

In many parishes the common pastures, meadows and greens were also enclosed and divided between new owners. Sometimes they disappeared altogether; sometimes fragments were left. Farmers were generally given additional acres to compensate for their loss of common grazing, but the landless labourers were not – although they were often the hardest hit, as their single cow may have

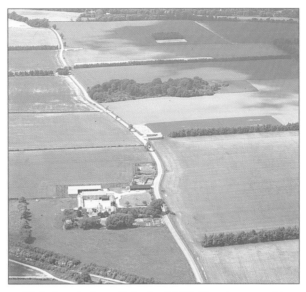

112 Enclosure landscape, Dullingham (NW). The only remnant of the earlier landscape is the winding road, flanked on either side by new rectangular fields.*

made the difference between survival and starvation.

The nineteenth century was a period of rapid population growth. Clay or brick cottages were built on verges or encroached on remaining pieces of common ground, and small-scale local brick industries flourished as a result. In the towns (which had remained more or less static in size since about 1500), new suburbs grew up as landowners built terraces of small 'two-up, two-down' cottages for the agricultural workers who moved to the towns in a steady stream. By the end of the century, most people in England lived in towns or cities, and the villages saw their populations declining as farmers (and sometimes their labourers) moved out to the newly enclosed farms and other villagers moved to the towns. Settlements continued to shift in the landscape, as the example at Mepal shows.

Local industries flourished. Some – like the coprolite diggings – were relatively short-lived; others – like the brickworks – expanded and continued in production. The railways were built into Cambridgeshire from the mid-nineteenth century, and major junctions and shunting yards grew up at Cambridge, Peterborough and March.

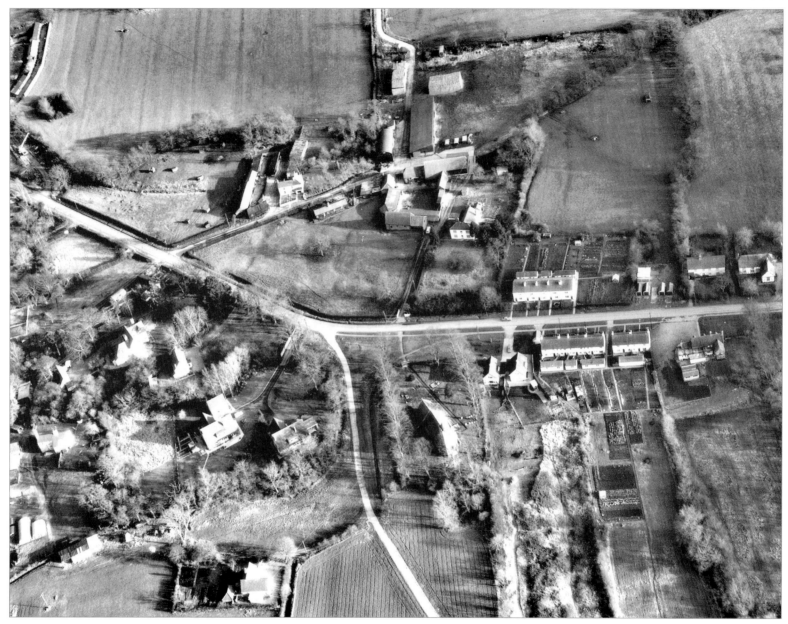

113 ENCLOSED GREEN, HARDWICK* (E)

The green at Hardwick was enclosed in 1836 at the same time as the common fields. Villagers with sufficient field land were allotted some acres in lieu of their grazing rights, but landless villagers were not compensated and some suffered heavily from the enforced loss of their one or two cows and possibly a few sheep, which might have made all the difference where their other income was at or below the breadline.

After enclosure, the dismembered green was mostly used for building land and a public road was constructed diagonally across it. Its eastern boundary, now marked by a hedgeline, leaves the modern road near the left of the photograph and then travels south (right) behind farm buildings which have been built on the old green. Just past the farm the hedge turns sharply west, and its line is continued over the main road to become the southern boundary of the churchyard. Its western boundary is marked by the edge of the ploughed fields; its northern boundary by a meandering stream which carries the line back to the main road.

The pre-enclosure green carried a number of public buildings and facilities: the church, a smithy, the pound for stray livestock and the village well. Although all of these except for the church and well have disappeared in Hardwick, they are often a useful indicator alongside other evidence of previously open land in other settlements.

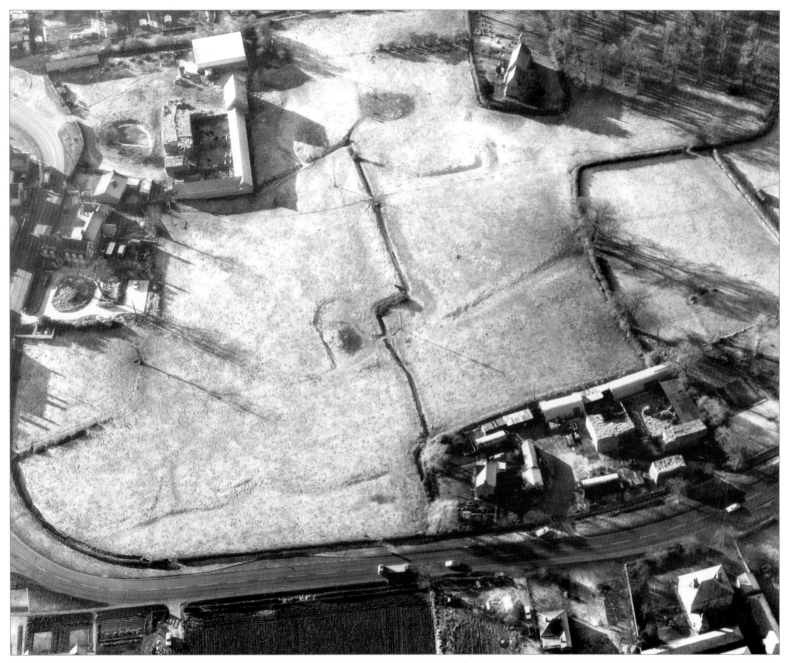

114 SHIFTED VILLAGE, MEPAL (SW)

The small thirteenth-century church at Mepal (top), the only church in fenland with neither steeple nor tower, reflects the size and wealth of this isolated settlement. The church was derelict in 1810 and most of the villagers were engaged in livestock farming, using the grazing of the surrounding fenland.

In the field below the church are the ponds, house platforms and ditched property boundaries of an earlier settlement. The village's original main street, which used to run to the west of the church is at the top left. The modern village lies away from the church along a road which skirts the older village.

There is no documentation of this shift in the focus of the village away from the church. The most likely explanation is a catastrophic fire which occurred sometime between 1861 and 1871, and as a consequence of which the village population fell from 510 to 397.

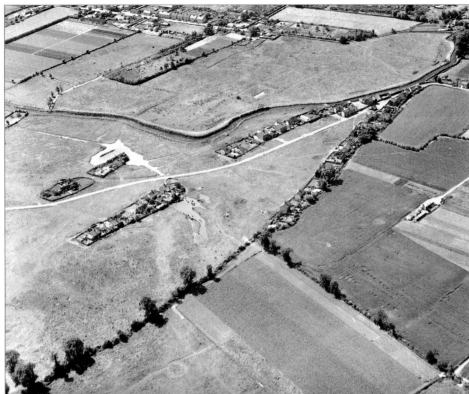

115 ENCROACHMENT, SOHAM EAST FEN COMMON* (S)

Along Soham Lode a funnel-shaped common broadens out from the west (right). Along the hedgeline dividing the common from the fields to the north (bottom) are the small gardens of cottages which were built piecemeal on the common by the landless, a process echoed by the similar row next to the lode.

To the left, where the common widens out, other cottagers have gradually enclosed small pieces of land for their houses, creating three islands of settlement in the grazing land, which might gradually grow to cover the common with small irregularly shaped properties.

116 ENCLOSED FIELDS, TOFT* (SW)

The church at Toft has been separated from the rest of the village by fields since at least the later Middle Ages. Church Lane, running past the church, was an old field road passing between ridges from the right of the church and along an old headland to the left of the church, before twisting left and right between old enclosures.

The western hedge along Church Lane separates the ploughlands of that field from its headland – where the ploughman would have turned his plough team – and this means that this field cannot have been ploughed after the hedge was set. It appears to have been planted during the fourteenth century, when much arable land was converted to pasture. The field was used to pasture the village livestock until enclosure in the early nineteenth century, and the hedge was planted to prevent the animals from straying.

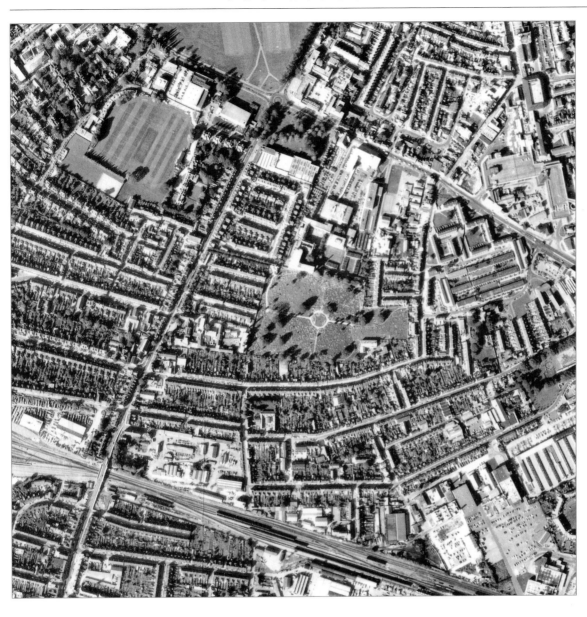

117 VICTORIAN SUBURBS, CAMBRIDGE* (NW)

Until enclosure of the eastern fields of Cambridge between 1807 and 1811, development outside the medieval town was limited to some ribbon development along the main roads. Mill Road (from top centre to bottom left) had been a field road.

Much of the area shown to the right of Mill Road was allotted to Gonville and Caius College at enclosure and the college released the land for building piecemeal and on long leases. The initial developments came immediately after enclosure between *c.* 1810 and 1840 as smaller private landowners built new housing for the rapidly growing population north of the land held by the colleges. The area shown here was all originally within the parish of St Andrew the Less, until new churches were built in the late nineteenth century. The population rose from only 252 in 1801 to 6,651 in 1831.

The opening of the railway in 1845, combined with the new rights of college fellows to marry, meant that the demand for housing land increased. Gonville and Caius released some land for semidetached and terraced villas, interspersed with small terraced houses. By 1861 the population had virtually doubled again, reaching 11,848.

The north-western end of Mill Road was built up by 1850 and most of the rest of the area as far as the railway was built on between 1850 and 1870. By 1891 the population of the area had again more than doubled, to 25,091.

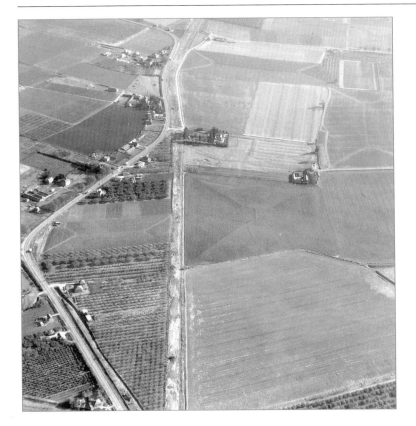

The Old Well Creek flowed from Outwell to Wisbech until silting blocked its outfall, soon after *c.* 1300. It was canalized in 1794 – hence its unusually straight line – and by 1848 was carrying nearly 30,000 tons of goods and coal a year. Competition from a steam tramway, which ran alongside the canal from 1884, was too great and the canal had gone out of use by 1894. It was subsequently filled in and can now be traced on the ground as a broad earthwork. The farm to the right of the canal in the middle distance lies beside Outwell Basin, one of the numerous trading hythes along Well Creek.

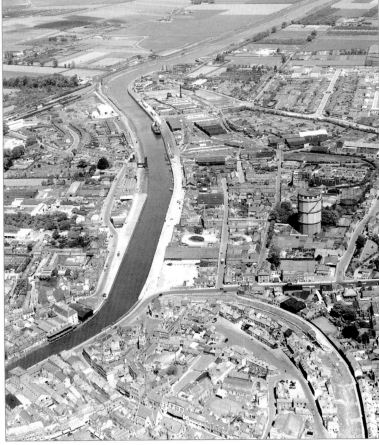

119 WISBECH PORT* (NW)
Straightening and dredging the River Nene meant that by the nineteenth century Wisbech had become the biggest corn-shipping port in the country. Dense nineteenth-century warehousing lines the riverbanks at bottom left. Trade was affected by the arrival of railways from London and Peterborough in the mid-nineteenth century (the latter enters the left of the photograph making straight for the northern section of the River Nene near the top right). In 1889 the river was widened and new quays constructed immediately north of the old port, along the section of the river in the centre of the picture. Ship-building during the nineteenth century was carried out in yards which lie beneath the present rebuilding to the right of the modern docks under the petroleum depot. These quays were rebuilt in 1940 and a petroleum depot established on the right of the river.

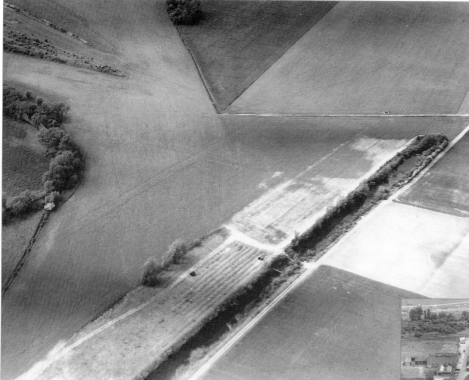

120 COPROLITE DIGGINGS, TRUMPINGTON

The narrow parallel ridges in fields in Trumpington are all that remain of an industry which flourished between *c.* 1850 and 1870: coprolite digging. A 12 inch thick phosphorus-rich mineral seam along the edge of the Cambridgeshire chalk ridge was excavated and then ground up as fertilizer. The industry was killed by the importation of cheap fertilizer from South America.

The coprolites were dug out of successive narrow open trenches, usually between 12 and 20 feet deep, which followed the seam across the countryside. Agricultural labourers made good earnings from the industry, but it was dangerous work with little shoring or other safety measures, and some fatal accidents occurred.

121 CAMBRIDGE GASWORKS AND PUMPING STATION* (S)

In 1884 the Cambridge gasworks were built on Riverside near the River Cam and followed a decade later by the steam pumping station, the 170 foot high chimney of which can be seen to the left of the coal gas (and later natural gas) storage tanks. The gasworks produced domestic gas for lighting and cooking into every home; the pumping station took mains sewerage and water from the public drains to a treatment farm at Milton. Together they brought domestic life in Cambridge into the modern era.

The sheds next to the chimney contain enormous steam and gas pumping engines and boilers.

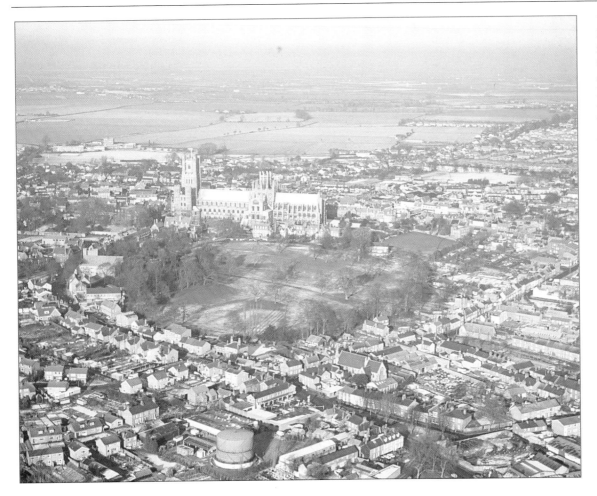

122 ELY IN 1850 (NW)

Early nineteenth-century Ely was hemmed in by the river on the east and by the open fields to the north, west and south. The agricultural labourers in the region around Ely suffered years of intense poverty around the turn of the eighteenth century, and this brought them into Ely to look for work away from the land. Terraced housing grew up close to the walls of the cathedral precinct.

Enclosure came between 1844 and 1848. As each farmer's land was now concentrated in one place, rather than scattered about the parish, those landowners whose farms lay nearest the town were able to do well out of speculative building. Suburbs of terraced houses and middle class villas were built for the rising population by local builders along the roads leading into Ely. This rapid building of small houses was encouraged by the three railways which met in Ely by 1850.

The increase in small, low-cost houses created areas where building land was at a premium near the town centre. Here, mortality and infectious diseases were rife — more than half of the town's housing stock in 1850 were poor dwellings whose streets were lined with 'stinking gutters'. Enlightened local government did its best to ameliorate these conditions and succeeded to an admirable extent in the succeeding decades.

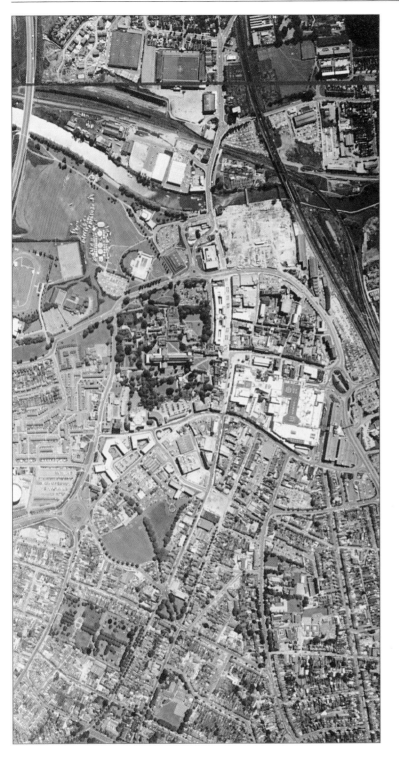

123 NINETEENTH-CENTURY PETERBOROUGH (S)

The medieval heart of Peterborough lay in the centre of this view, including the minster church, the medieval market and town to the west and north, and the river. In 1851 the Great North Railway built its station and marshalling yards to the west of the old town, creating a major railway centre. The subsequent expansion was rapid. New suburbs grew up for the railway workers near the station, with long lines of back-to-back terraced housing for the new working classes of the Industrial Revolution. Industrial development followed the introduction of a transport infrastructure. This view vividly shows the expansion of nineteenth-century suburbs to the north of (below) the cathedral.

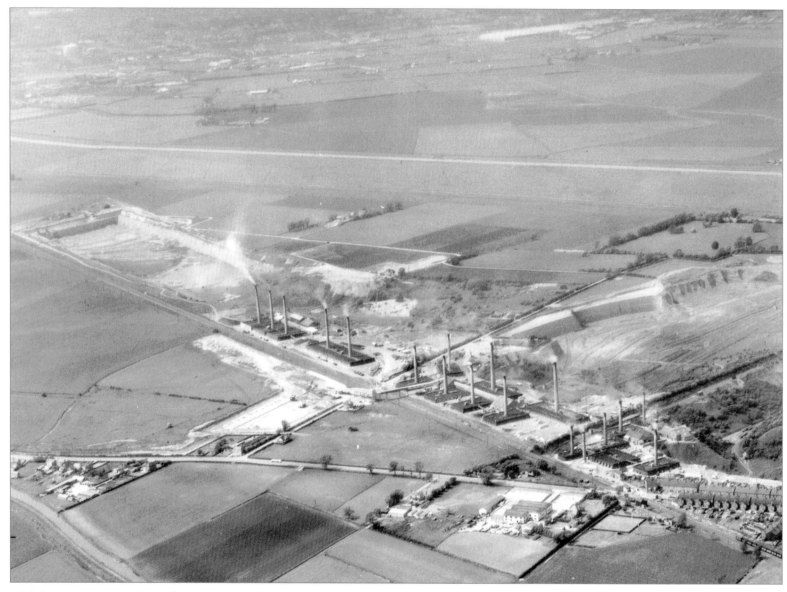

124 BRICKWORKS, WHITTLESEY (NNW)

In October 1853 the Eastern Counties Railway began to sell off plots of land on the north side of the railway to would-be brick manufacturers, and brickmaking quickly developed into a major industry on the western outskirts of Whittlesey. By 1898 the Whittlesea Central BCI (Brick Construction Industries) was formed and bought up several of the smaller brickworks, transforming them into the No. 1 and No. 2 Works. In the 1960s the company was owned by the National Coal Board, who sold it to the London Brick Company in 1974.

The fenland clay, laid down in marine inundations up to three thousand years ago, is being extracted with industrial machinery to feed the brickworks. The large open quarries from which the clay is dug can be seen behind the works. The railway line, the existence of which was crucial to the opening of the brickworks, crosses diagonally from left to right. The factories are clearly closely linked with it.

The main road between Whittlesey and Peterborough crosses the railway line, travelling almost straight across the photograph to its intersection with the King's Dyke, a medieval drainage ditch.

There were many of these small brickworks across Cambridgeshire in the mid-nineteenth century, turning out the characteristic yellow brick which can be seen everywhere in nineteenth-century buildings. The development of improved industrial processes by the larger works, together with the early twentieth-century depressions, tended to put them out of business and few now survive in working order.

10: MODERN TIMES

After 1900

Landscape change is progressing more quickly now than it has ever done before, as large tracts are developed for large-scale projects initiated by the state or by business.

During the two world wars, many acres of farmland across Cambridgeshire were compulsorily purchased for use as airfields. Some survived the interwar years to be reused between 1939 and 1945, but most have now been decommissioned. The airfield at Duxford, now used by the Imperial War Museum, is an unusual relic. Similarly, Second World War searchlight stations and anti-aircraft batteries have disappeared or lie neglected. Appropriately, the American Cemetery at Madingley is the most carefully tended of all these war-related sites.

Small industry is still a feature of the county. Some – like the brickworks and cement factories – have been taken over by larger concerns; others continue to develop. Many of the agricultural smallholdings set up by the county council and the Land Settlement Association are still farmed, while the science park at Milton is an impressive testimonial to the diversity of the new technologies.

Rapidly rising population has meant that new suburbs – some built before 1939 and some after 1945 – have been constructed in almost every city, town and village. In some cases, entirely new settlements have been

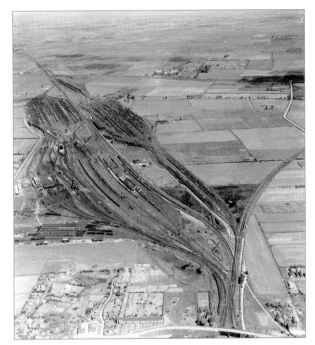

125 March (NE). These sidings were built in the 1930s and were among the largest in Europe at the time.

built from scratch, as at Bar Hill. In other cases, nineteenth-century slum suburbs have been gentrified, displacing former inhabitants to newly built council estates on the outskirts.

New roads have been constructed – the most dramatic in landscape terms has been the M11 motorway – while older roads have been metalled and upgraded to dual carriageways, or have been straightened. To the regret of many, railway transport has diminished in importance and withered away.

In rural areas, often the most frequent landscape change outside the village has been the construction of golf-courses where, like medieval market-founders, farmers have found that the loss of a few acres to agriculture has reaped far greater profits from the new emphasis on leisure pursuits.

In some places the countryside has benefited. Public awareness of the threat of large-scale landscape change to historic landscapes has meant that some areas have been preserved by the Cambridgeshire and Bedfordshire Wildlife Trust, the Cambridge Preservation Society and English Nature, while designation as a site of special archaeological or scientific interest offers some protection against unthinking change. The challenge for our century must be to learn truly to value the past, and to glory in the fact that its value is not material.

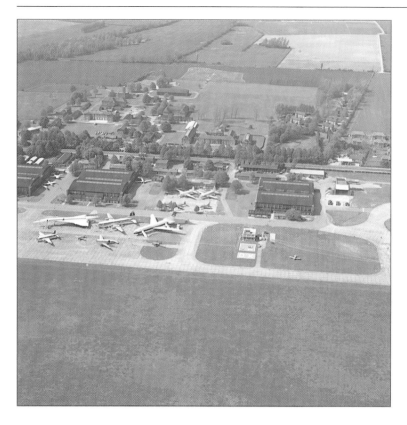

126 AND 127 AIRFIELD AND RUNWAYS, DUXFORD

Numerous small airfields were established in East Anglia during the First World War, and many have since been ploughed up and returned to the farmers from whom they had been compulsorily purchased. That at Duxford, covering 138 acres, continued in use after the war ended in 1918 and was used first as a flying school and then, after 1924, as a fighter station, home to up to three squadrons at a time. After the Second World War the airfield continued in use as a fighter base, usually for two squadrons, until it was closed down in 1961. In 1972 the Ministry of Defence allowed the Imperial War Museum to open a museum for historic aircraft on the site, and it has since developed into one of Britain's major museums.

The new headquarters building was constructed in 1934 and equipped Duxford to become the centre of an RAF sector which controlled air defence over the eastern coastline during the Battle of Britain. The hangars are historic monuments in their own right, having been constructed by German prisoners of war during the First World War.

The runways were originally grassed, and were only reconstructed in concrete after the site was leased to the US Air Force between 1942 and 1943. For a short period between the closure of the base and its opening as a branch of the Imperial War Museum, the runways were used for gliding and motor-car racing. Today they are still used for gliding and also for the impressive displays of historic aircraft in flight on special occasions.

128 CEMENT WORKS, BARRINGTON (NW)

The great ridgeways which cross Cambridgeshire from west to east, falling away into the Cam valley, are largely made up of chalk overlain with a layer of clay. In the medieval period and up to the nineteenth century, the chalk was extracted as a soft building stone, which can be seen in many nearby churches and houses.

By 1891 a cement works had been established next to the quarry at Barrington, digging the limestone out of the ridge to make 300 tons of Portland cement a week. The company moved through various hands until it was taken over by the Rugby Portland Cement Company in 1962. The works were immediately expanded, and by 1968 they produced 500,000 tons of cement a year and employed more than 300 people.

A branch railway was built to link the works with the main Cambridge–London line at Foxton. It can be seen crossing the road near the main factory entrance. Today, tankers carry the cement to different destinations.

The steam from the chimneys can be seen over much of south Cambridgeshire, while the quarry is enormous and an impressive testimony to the usefulness of the local chalks in industry.

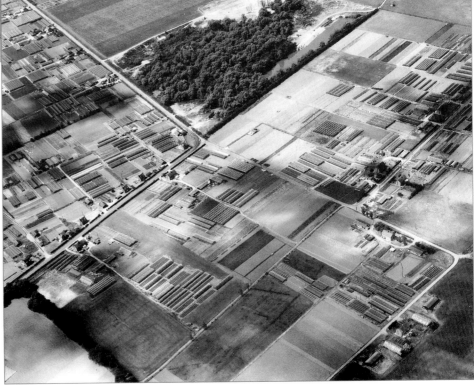

129 AGRICULTURAL SETTLEMENT, GREAT ABINGTON (W)

These smallholdings were created in the aftermath of the Great Depression by the Land Settlement Association. The association bought a local farm at Great Abington in 1936 and converted it into smallholdings of about 10 acres each for people from as far afield as South Wales and County Durham who were looking for new directions. The smallholdings were initially used for market gardening, and pig or poultry rearing; later, tomatoes, lettuces and greenhouse produce were introduced. By 1962, forty-six of these small farms had been established. There are similar colonies in many places in Cambridgeshire, including many set up by Cambridgeshire County Council after the First World War, when agricultural depression had hit many farms hard and there were demobbed soldiers looking for a livelihood.

130 MARKET GARDENING, FEN DRAYTON (SW)

Market gardening had been practised at Fen Drayton since the mid-nineteenth century over an area of about 230 acres, and many small farmers also kept orchards. The proximity of London and the burgeoning towns of Cambridge and Peterborough offered ready markets for produce. These allotments are some of the fifty-four of between 3 and 5 acres created in 1936 by the Land Settlement Association after it had bought a 350 acre estate at Fen Drayton. The first settlers, from County Durham, helped to build the access roads and tracks through the settlement. The allotments were used for pigs and poultry and also for growing tomatoes, lettuces, celery and autumn flowers, often in conservatories.

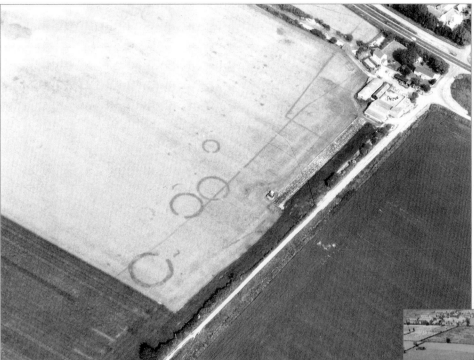

131 SEARCHLIGHT STATION, FULBOURN
(ESE)
These circular crop marks might be mistaken for the ring ditches around Bronze Age barrows. They are, in fact, the remains of batteries of searchlights which were installed during the Second World War to intercept enemy aeroplanes. The ditches are broken, not continuous as the majority of prehistoric ring ditches would be.

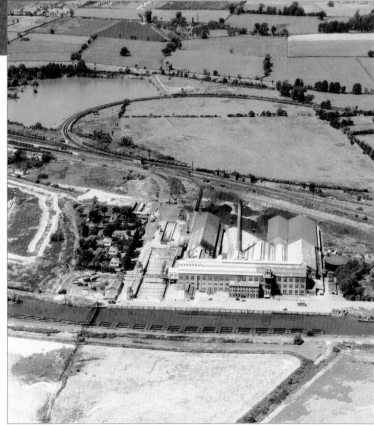

132 SUGAR-BEET FACTORY, ELY* (W)
During the 1920s the Government encouraged the introduction of sugar-beet into East Anglia and built a network of eighteen local factories to process the crop. The First World War had highlighted the pre-war agricultural depression and the shortage of home-produced foods, including sugar. The new policy was intended to deal with both these problems, and it was very successful.

Many of the factories, like this one at Ely, were situated next to rivers since large quantities of water were needed to clean and boil the crop before it was turned into sugar. This had the additional advantage that the waterways could also be used to transport the beet, coal and limestone all needed in the process. Railways were also an important factor in the transport of the beet and its product, and in the 1930s over 50 per cent of the crop was carried by rail.

The Ely factory was ideally placed: it stood on the banks of the Ouse and beside the railway. However, technical improvements in the process led to the closure of seven factories during the 1980s. The Ely factory was one of the first to go, in 1981.

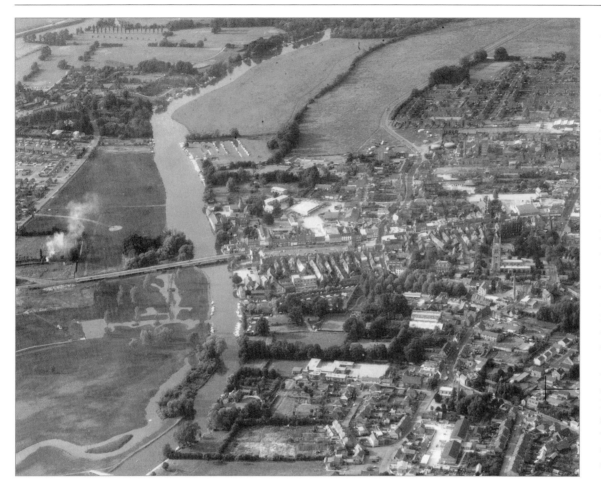

133 ST NEOTS (N)

The original village of St Neots grew up around a major market founded by the late Saxon priory which stood until 1539 on the east bank of the River Ouse, just north of the present bridge and market. The intersection of road and river brought a great deal of trade into the town. The remains of substantial wharves can be seen immediately north (above) and south (below) of the eastern side of the bridge. Although they originated in the Middle Ages, they were much developed by local entrepreneurs during the nineteenth century who traded in products including beer, bricks, coal, salt, slates, Canadian barrel staves, timber and oils.

The imposing houses of these well-to-do merchants and industrialists can be seen on Market Square, the large open space immediately east of the bridge. The houses of working people line the narrow lanes and courts which led off from the High Street.

A major papermill stood to the north of the priory site, where a large factory continued this tradition well into this century. It employed a large labour force for whom a suburb of low-cost terraced housing grew up to the east of the mill. The narrow streets and small back gardens can be seen in the north (near the top of the photograph).

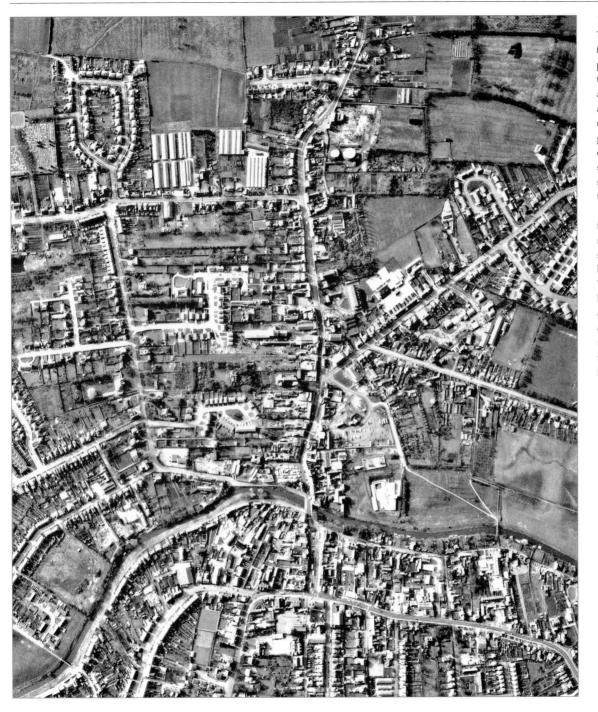

134 MARCH (S)

The River Nene was diverted through the fen island of March during the late Saxon period. The medieval town lay a little way to the south of the river, but the trade plying along the River Nene was an irresistible attraction and the town gradually moved north to lie alongside the river. A market grant was received in 1670 and a market laid out just to the south of the river crossing shown in the photograph. It was not very successful, and another market was laid out to the north of the river crossing in 1821.

After March became the centre for fenland railways, the town thrived. The new market became the heart of the town, as suburbs to house the railway workers were built between it and the station to the north. The beautiful ornamental cast-iron fountain built at the northern edge of the nineteenth-century market to commemorate the coronation of King George V in 1911 is a monument not only to the occasion but also to the civic pride and prosperity which paid for it.

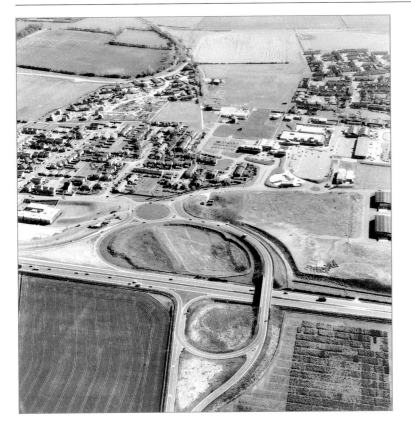

135 MODERN SUBURB, BAR HILL (SW)

Like the planned developments of the Middle Ages, village planning continues today. Work began on the new village at Bar Hill in 1965, and by 1985 the population had reached just less than 2,500. The houses have been laid out in closes which lead off from the village ring road, and which surround a central green containing a shopping centre, primary school and library. The dual carriageway which runs between Cambridge and Huntingdon (the east coast and the Midlands) lies immediately to the north of Bar Hill. The settlement was carefully planned to include light industry (right), domestic housing plus such amenities as the library and commercial centre. A large superstore which serves the area to the north and west of Cambridge stands immediately to the south of the large car park (right centre).

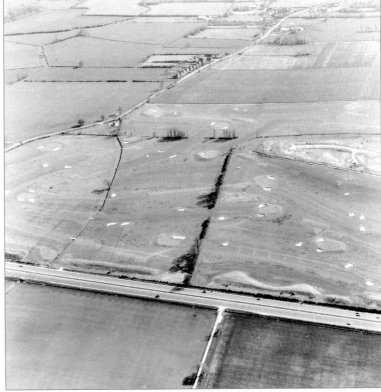

136 GOLF-COURSE, BAR HILL (S)

The golf-course is the archetypal landscape form of rural England in the late twentieth century. Here at Bar Hill, an eighteen-hole course was opened in 1975 by a new hundred-room hotel built in 1973–4. The bunkers and fairways have been constructed by enormous land-moving machines, and saplings have been planted which will mature over the next generation. This 134 acre landscape is devoted entirely to leisure and makes an interesting comparison with the ritual landscapes of the prehistoric period.

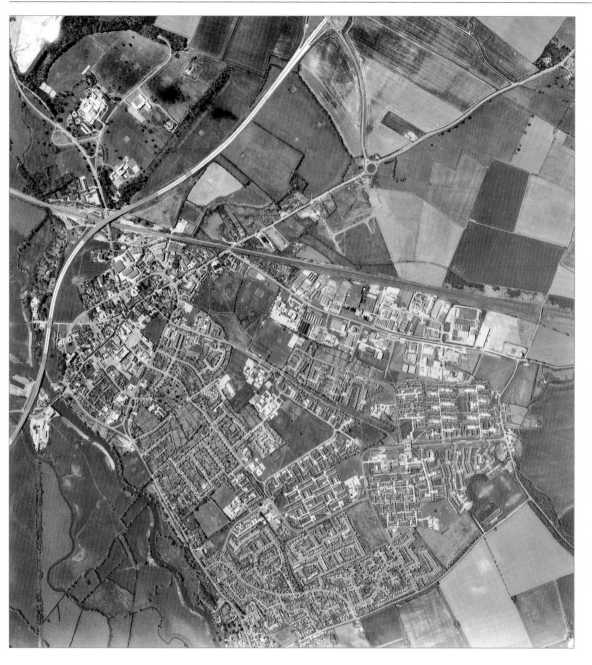

137 MODERN DEVELOPMENT IN HUNTINGDON (W)

The modern development of Huntingdon has been inhibited by the low-lying land along the River Ouse to the south and the line of the nineteenth-century railway to the west. The medieval town lay along Ermine Street, the Roman road which crosses from south-east (centre left) to north-west (top right), and was enclosed by the lozenge-shaped ring road. Ribbon development occurred along Ermine Street during the nineteenth century, but it is in this century that Huntingdon has been transformed by large-scale corporate planning.

A modern dual carriageway snakes its way across the older lines of communication. Substantial areas of the old town have been demolished and replaced with civic and commercial buildings and large new estates have been constructed, particularly in the decades since 1945, towards the east and north-east of the original centre.

Here, the enclosed closes and squares of post-war development are plainly visible, as architects attempted to recreate communities in a new context. At the heart of the large Oxmoor estate in the east lies the recreation ground of two schools: a primary school in the south-west and a secondary school (now transformed into Huntingdon Regional College) in the north-east.

In the far south-west (top left) of this view there is another typically modern development: a service suburb including a secondary school, a new hospital and police headquarters within the grounds of a country house.

138 M11 INTERCHANGE, GIRTON (SW)

The M11 was constructed during the 1980s to bring Cambridgeshire within commuting distance of London, as well as to provide the necessary infrastructure for industrial development in the new 'silicon valley' now that the railways are being downgraded. Alternating between two and three lanes, it allows access to north-east London within an hour and cuts across the landscape with the same lack of interest in antiquity shown by Ermine Street in Caxton.

The motorway crosses from left to right, with two graceful loops allowing inter-changing traffic access to and from the Cambridge ring road. This latter road (between top right and middle left) continues to connect Cambridge to the east with Ipswich and Europe, and to the west with Bedford and the Midlands.

The old Roman road between Cambridge and Godmanchester runs across the bottom of the photograph (left to right), with feeder roads linking it with the ring road. It is an appropriate coincidence which places this road, the so-called 'Via Devana', beside the modern motorway. Constructed almost two thousand years apart, they were both the result of state planning and investment in road transport on a scale which was unknown in intervening centuries.

139 CAMBRIDGE SCIENCE PARK (S)

During the late 1970s and '80s, Trinity College invested in the development of an industrial zone devoted to encouraging small industry to create new products based on the results of technological, electronic and industrial research within the university.

This successful venture was carefully sited on the north side of the town, to give good access to the main road between the east coast and the Midlands. This dual carriageway runs across the north (bottom) of the photograph, linked to the science park and the town by a main road, reflecting the decreased importance of the railways in linking businesses and outlets.

A ring road unifies the scattered buildings of the science park, while curving access roads allow each business the appearance of space within landscaped grounds. Indeed, a carefully landscaped lake and green parkland says much about the values of late twentieth-century business, as it provides a setting which subtly enhances the appearance of the buildings and business status.

Immediately to the south-west of the junction (bottom left) are two buildings belonging to Napp Laboratories, the exciting architectural structure of which was among the first buildings to be built.

140 MODERN ESTATE, CHERRY HINTON (W)

The car and the railway have transformed those villages, like Cherry Hinton, which lie just a few miles from a large town. Here, commuter housing has transformed the village from rural community to suburb. This view shows how modern developments have been defined by the pattern of enclosure fields, as well as the order in which the fields have become available for building. At bottom left is the older development with individual buildings placed around a central green. The social aim in building this estate appears to have been to encourage its inhabitants to see themselves as a single community, with a common focal point linked by a grid pattern of streets.

To its right is the new estate of terraced dwellings in small closes, the access roads of which lead off an outer ring road. The emphasis here is on recreating small communities and on individual identification with different parts of the settlement through varying architecture.

Modern industrial developments lie immediately to the west of the new suburbs, while Cambridge, with its own attractions for workers, is just a mile or so away.

The stresses and effects of modern industrialization have transformed villages. The benefits to the villages are that, in some cases, they have been saved from virtual depopulation by commuter settlement. However, the negative effects must include a loss of connection between village dwellers and the rural industries, as the settlements have been transformed into suburbs rather than free-standing communities.

141 NATURE RESERVE, CHIPPENHAM (N)

Chippenham Fen Nature Reserve occupies a low basin at the edge of the fen which remained undrained until it was partly reclaimed between 1790 and 1800 by the creation of an extensive network of drains. Two areas of woodland were planted at the same time: Jerusalem Wood, which runs through the centre of the reserve, and Forty Acre Wood, which occupies a broad belt to the east of the fen.

The reserve preserves many fenland landscapes which drainage has destroyed elsewhere. These include sedge fen with much local scrub, and damp meadow grassland – inundated in winter and producing the sweet early hay in the spring on which were made the fortunes of so many seventeenth- and eighteenth-century cattle farmers. The wetter areas carry alder, birch and willow carr woodland, and the mature woodlands with many native species, including oak, ash, beech and elm, stand on the higher areas. The variety of habitats for wildlife encourages a rich flora and fauna: in one year, fifty-three species of birds were counted.

The site is now managed by English Nature on behalf of the Chippenham estate, and parts of the reserve are open to members of the public during specified times of the year.

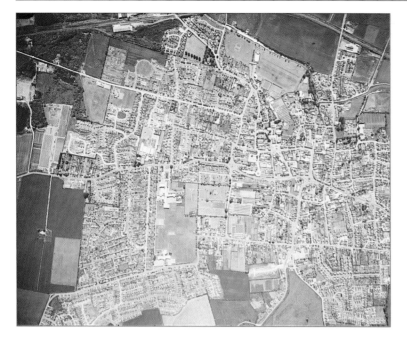

142 WHITTLESEY* (S)
Whittlesey has always been one of the most populous fenland towns, and since the nineteenth century a combination of trade, industry – in the form of brickworks – and the proximity of Peterborough have encouraged the town to grow far beyond its medieval origins. This view shows the characteristic cul-de-sac pattern of modern suburbs, and the playing fields surrounding the Sir Harry Smith Community College which lies to the left of the market and churches of the old town.

BIBLIOGRAPHY

Astbury, B.K. *The Black Fens*, Providence Press, 1987

Beresford, M. and St Joseph, J.K. *Medieval England*, Cambridge University Press, 1979

Browne, D. *Roman Cambridgeshire*, Oleander, 1977

Darby, H.G. *The Medieval Fenland*, David & Charles, 1974

——. *The Changing Fenland*, Cambridge University Press, 1983

East Anglian Archaeology: Fenland Project, Reports 1–6, Nos 27, 35, 45, 55, 56

Frere, S.S. and St Joseph, J.K. *Roman Britain from the Air*, Cambridge University Press, 1983

Green, M. *Godmanchester*, Oleander, 1977

Haigh, D. *The Religious Houses of Cambridgeshire*, Cambridgeshire County Council, 1988

Harrington, P. *Archaeology of the English Civil War*, Shire, 1992

Haslam, J. 'The Development and Topography of Saxon Cambridge' *Proc. Cambridge Antiquarian Society* 72 (1983), pp. 13–19

Hillier, R. *The Clay that Burns*, Cambridgeshire Libraries, 1981

Institute of Historical Research. *Victoria History of the County of Cambridgeshire*, Vols I–IX

——. *Victoria History of the County of Huntingdonshire*, Vol. II

——. *Victoria History of the County of Northamptonshire*, Vol. III

Royal Commission on Historical Monuments. *City of Cambridge*, Vols I and II, HMSO, 1959

——. *West Cambridgeshire*, HMSO, 1968

——. *North-East Cambridgeshire*, HMSO, 1972

Taylor, A. *Prehistoric Cambridgeshire*, Oleander, 1977

Taylor, C.C. *The Making of the Cambridgeshire Landscape*, Hodder, 1973

——. *The Archaeology of Gardens*, Shire, 1983

——. *Village and Farmstead*, George Philip, 1983

——. 'Somersham Palace, Cambridgeshire' in M. Bowden, D. Mackay and P. Topping, (eds), *From Cornwall to Caithness*, British Archaeological Reports 209 (1989), pp. 211–24

Wade-Martins, P. *Norfolk from the Air*, Norfolk Museums Service, 1987